Every Picture Tells a Story

Acknowledgements

Much of the information on several of the pictures is indebted to detailed research by others, published as follows:

Jeannie Chapel, *Victorian Taste. A complete catalogue of the paintings at the Royal Holloway College*, A. Zwemmer Ltd, London, 1982 (Luke Fildes, **Applicants for Admission to a Casual Ward**, and William Powell Frith, **The Railway Station**);

Roy Strong, *'Sir Henry Unton and his Portrait: An Elizabethan Memorial Picture and its History'*, *Archaeologia*, XCIX, 1965, pp. 53-76; Roy Strong, *Tudor and Jacobean Portraits*, National Portrait Gallery/HMSO, 1969 (Unknown artist, **Portrait of Sir Henry Unton**);

Malcolm Warner, catalogue entry for **Ophelia**, *The Pre-Raphaelites*, The Tate Gallery/Penguin Books, 1984 (John Everett Millais, **Ophelia**).

Photographs of paintings and drawings were all supplied by, and are reproduced courtesy of the respective museums, except for the paintings by Richard Eurich, Luke Fildes, William Frith and James Tissot, photographs of which were supplied by the Bridgeman Art Library. Richard Eurich's **Gay Lane** is reproduced by kind permission of the artist.

Phaidon Press Limited, Musterlin House, Jordan Hill Road, Oxford, OX2 8DP.

First published 1989
© Phaidon Press Limited 1989
Text copyright 1989 Rolf Harris

Book designed by Ian Gwilt and Stephen Raw of Bookforms
Typeset by Bryan Williamson, Manchester

A CIP catalogue record for this book is available from the British Library.

ISBN 0 7148 2554 9

Printed and bound in Great Britain by Ebenezer Baylis & Son Limited.

Every Picture Tells a Story

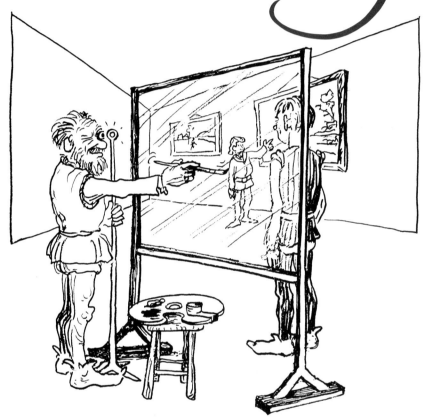

ROLF HARRIS

Phaidon · Oxford

CONTENTS

About this book	5
The Wreckers by George Morland	6
Sir Henry Unton by an unknown artist	8
Southwold by Sir Stanley Spencer	12
Sadak in Search of the Waters of Oblivion by John Martin	16
Houseless and Hungry by Sir Luke Fildes	20
A Lion Hunt by Peter Paul Rubens	24
The Railway Station by William Powell Frith, and **Gare St. Lazare** by Claude Monet	26
Ophelia by John Everett Millais	30
Niccolo Mauruzi da Tolentino at the Battle of San Romano by Paolo Uccello	34
Gay Lane by Richard Eurich	38
The Fire of London by an unknown Dutch artist	42
The Alchemist in search of the Philosopher's Stone, discovers Phosphorus by Joseph Wright of Derby	46
Too Early by James Tissot	50
A Winter's Scene with Skaters near a Castle by Hendrick Avercamp	54
The Doll's House by William Rothenstein	58
The Chariot Race by Alexander von Wagner	60
And When Did You Last See Your Father? by William Frederick Yeames	64
The Execution of Lady Jane Grey by Paul Delaroche	66
About the painters	70
Index	71

About this book

When I was a lad in Perth, Western Australia, my father used to get copies of a magazine called *Studio* sent out to him from England on a regular basis. I used to love going through each edition, losing myself in the paintings which in those days were reproduced in black and white. Little did I know that one day I would be able to see some of the originals.

I can remember reading one article in particular; it was about the artist Sir Frank Brangwyn and how he created his wall paintings, or murals. The photos in the magazine showed his early rough sketches; then the scaffolding he worked on to transfer those sketches on to canvas; the method he used for 'scaling up' small sketches, and so on until the finished paintings were shown.

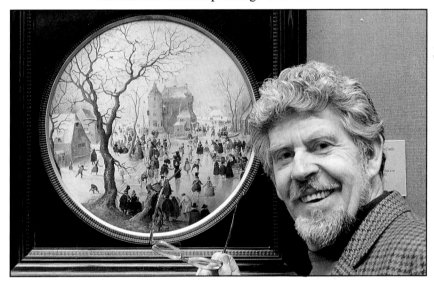

Rolf and *Winter Scene with Skaters near a Castle* by Hendrick Avercamp (see pages 54-7).

I don't know if you can imagine the thrill I had years later, as an entertainer, walking into Brangwyn Hall in Wales, (never in any way, shape, or form connecting the name in my mind), and suddenly being confronted by all these marvellous childhood memories, these huge exciting murals, full of life **and colour**. It was like a dream come true to see those pictures.

Nowadays, of course, a lot of books showing paintings use full colour reproduction, but there is still nothing quite so good as going to the gallery and looking at the pictures themselves. Quite often you will be surprised by the size of the painting. When I saw *Winter Scene with Skaters near a Castle* by Hendrick Avercamp, I was amazed at how small it was. There is so much tiny detail in the painting that I had assumed it would be a huge picture!

I hope you enjoy the exciting paintings and stories that I've chosen here, and that they will encourage you to go along to some galleries and look at some more. There are a lot of paintings out there just waiting to be enjoyed.

The WRECKERS

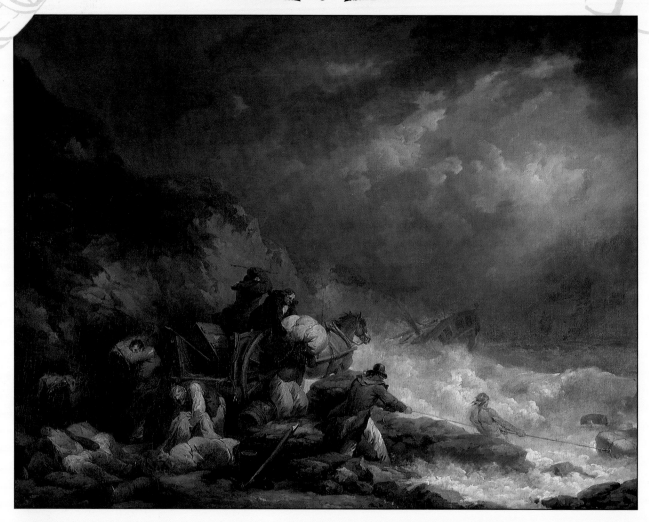

The atmosphere inside matched that outside, heavy, dark and oppressive. The only real difference was in the level of noise. Outside the gale was gusting, flapping and whining through ropes and wires, a non-stop jumble of sound. Inside there was a sort of silence like that of people waiting by a death bed. Any words that needed to be spoken seemed to come out in a whisper. Everyone appeared to be waiting, but for what?

A casual visitor to that particular inn on that particular night would definitely not have been made welcome. He would have been served, but the atmosphere and the attitude of the burly, warmly dressed men standing awkwardly around the room would have frozen off all attempts at casual conversation. A visitor would have finished his drink in silence and counted himself lucky to have got out of the place unharmed.

Every half-hour or so two of the men would finish up their drinks, drag on their topcoats and head out into the driving rain to take over

from the two men on watch on the cliff tops, about a quarter of a mile away. The night was ideal for their trade, the moon only glimpsed now and again through the scudding clouds, and gale-force winds blowing in from the Atlantic. The rain was nasty, but in a way also that made things better, cutting down visibility as it did.

The two relief men, at ten o'clock that night, reached the first of their companions on the cliff top; instead of appearing happy to be relieved, he grabbed at the bigger man's coat sleeve and pulling him close so that the words would not be whisked away by the wind he shouted, 'We've caught one! Can't get out now! Get the lads!' The two newcomers turned on their heels and fairly ran back the way they had come, knowing every inch of that path as only locals could. Their arrival back at the inn was met with very little fuss. Almost every man in the place left his drink and pulled on whatever other clothing he had before moving purposefully in single file down the path to the cliff top.

George Morland (1763-1804). *The Wreckers.* 1790? Oil on canvas, 40½ x 54½ in. (102.8 x 128.5 cm.). Southampton Art Gallery and Museums.

Curtains twitched at windows as they passed in the night, and back at the inn the few old-timers left behind exchanged knowing glances with the innkeeper. Not a word was spoken.

The two cliff-top watchers, separated as they were by a couple of hundred yards, were holding aloft their shuttered lanterns and moving them from side to side. The first of the new arrivals could clearly see the running lights of the ship as she was skilfully steered between the rocks and into the trap.

The two flickering lights, appearing as they did on the tops of two apparent headlands, must have seemed like a miracle to those on board the ship. At last, they thought, a safe bay in which to anchor and ride out the storm.

It was impossible to hear anything for sure in the howling gale, but a lively imagination might make out the panic-stricken cries as the men on board the ship suddenly realized it was all white water ahead. If you strained your eyes you might almost see the sailors dashing for the rigging to alter sails as they strived to bring their craft about... too late.

The men on the cliff top watch covered their lanterns and joined the wrecker gang as they picked their way carefully down the slippery cliff path. As they came down to the sea, they began to hear the grinding sounds of the ship as it was pushed further on to the rocks. Eventually, at sea level, they were able to watch as the masts, a darker black against the black of the sky, slowly keeled over. Sails parted company with spars, the splitting timbers sounding like gun shots in the night. And weakly above the continuous thunder of the waves, thin screams shuddered up into the night.

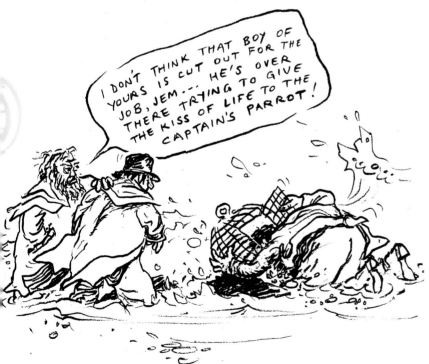

I DON'T THINK THAT BOY OF YOURS IS CUT OUT FOR THE JOB, JEM... HE'S OVER THERE TRYING TO GIVE THE KISS OF LIFE TO THE CAPTAIN'S PARROT!

All around the edge of the foam the men stood like huge, cloaked vultures, waiting for their pray to die.

The vultures began to wade in, uncoiling ropes from their shoulders to secure floating bits and pieces of cargo. God help any poor seaman or passenger who made it safely to shore. It would not do to have the authorities learn of this deceit. A pitiful call of 'Help! Help!' repeated over and over again from some foam filled back-water, and a sudden nod from one of the wrecking team to another, would bring about a well known and oft repeated course of action. The wrecker would wade off, thigh deep, reaching for the knife in his belt as he went, and in no time at all the cry would gurgle into silence.

The term 'wrecker' in America refers to people who salvage wrecks, but in England, the original meaning was much more sinister. 'Wreckers' were those who, as we have seen, purposely lured ships on to the rocks by using false lights and signals, with the intention of stealing as much of that ship's cargo as possible. Of course they also kept an eye out for genuine wrecks to plunder as well.

With all trade being carried out by sea, you can imagine how many ships from Europe, America, the Colonies and the Far East thronged the seas around England. On top of this there was quite a large sea trade from one town to another around the coast of Britain, so all in all there were quite a few wrecks. It was an accepted fact that anything washed up from the sea belonged to the finder, and cargoes of tea, Dutch gin, brandies, wines and bales of cloth were very welcome to the salvager.

Purposefully setting out to wreck a ship became almost a legitimate trade, like smuggling. Quite often, along the coast, everyone knew about it but kept very quiet, either because they were benefitting from it or because they were terrified of the gangs of wreckers who had no qualms about beating up or even killing anyone who might endanger their livelihood.

This painting by George Morland shows one such group of wreckers hauling bales and barrels out from the sea and loading them onto a waiting cart. You can see the body in the background, and to the right of the cart you can make out the sinking wreck. The whole scene, rocky, steep hillside and foaming seas, gives you some idea of how inhospitable and dangerous this stretch of coast is. The men, hefty and rough, are dressed in the baggy trousers usually worn by sailors, and heavy great coats with caped collars to protect them from the rain and the spray. They represent the rougher, seamier side of life which Morland, the artist, knew well, as he was very fond of keeping disreputable company.

He was best known for his paintings of quite different subjects, mainly rural scenes and pictures of children, so this frightening and dramatic work was quite unusual for him.

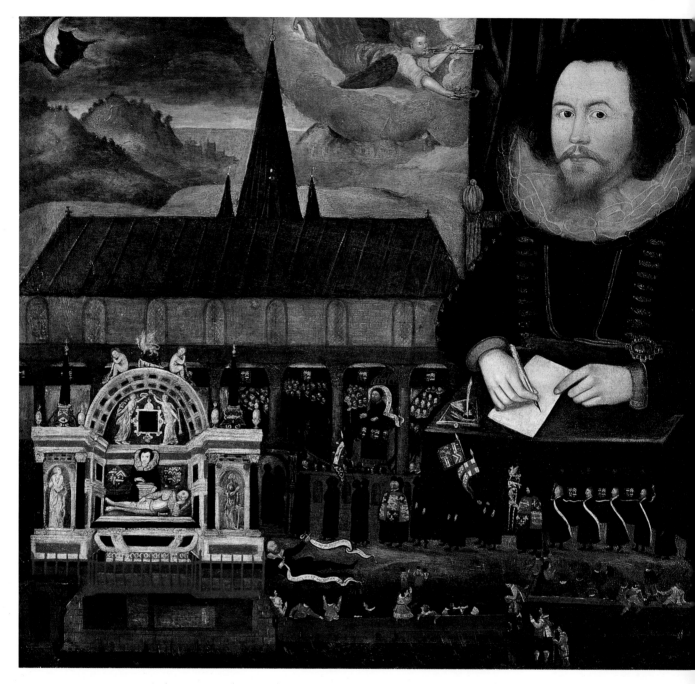

T he first thing that I noticed about this painting was that the life story of Sir Henry Unton unfolds in quite the opposite way to what you might expect. Most of our education in reading leads our eyes from top left across to the right, and so on downwards. This picture starts with Henry as a new-born babe down in the right-hand corner, and it continually feels wrong for me to follow his life story in an anti-clockwise way. The right-hand side of the picture deals with his life and eventual death, and the bottom and the left-hand side show the funeral procession and his final resting place with its elaborate carvings and pillars.

Centrally you have a portrait of Sir Henry, in quite a fashionable outfit, interrupted in his writing. On one side of him you have a skeleton clutching an hourglass, and the words *memento mori* as a reminder of death; and on the other side, the winged figure of Fame blowing a blast on a wind instrument as she flies in with a coronet, (Sir Henry was knighted for his part in the battle of Zutphen).

The second thing I noticed about the painting, which endeared the artist to me immediately, was that a lot of the figure work reminded me of cartoon characters. Look at the funeral procession across the bottom. It doesn't take much effort to imagine them

Unknown artist. *Sir Henry Unton.* 1596? Oil on panel, 64½ × 29¼ in. (163.2 × 74 cm.). London, National Portrait Gallery.

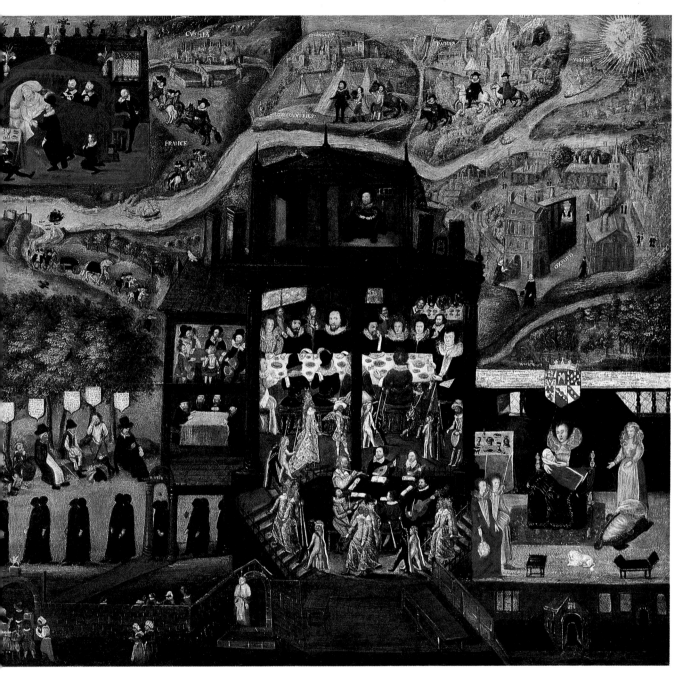

This simple, almost primitive painting, unfolding from right to left, is like a story board for a film showing one man's life in the late sixteenth century.

moving slowly from right to left across the picture. The whole painting is really, if you like to think of it that way, the forerunner of a cartoon book, telling a story in a simple and colourful way for even the most uneducated person to understand.

Let's start with the baby wrapped in red on his mother's lap. She is about to hand him to the nurse who stands with arms outstretched to place him in the cradle at her feet. The birth took place at the Unton residence of Ascott-under-Wychwood near Burford, and it is obvious from the ladies-in-waiting, the silver cups, dishes and pitchers, that the family is

well-to-do to say the least.

Move your eyes upwards past the coat of arms to the 'doll's house' like representation of Oxford. It is a delightful scene, easily understood; the young beardless Unton sits studying a book, while various scholars in long robes move about the town. Sir Henry did in fact study at Oriel College prior to 1573. Above Oxford you can see chunks of Europe, looking like marvellous *papier mâché* models you might have made for your model train set.

Sir Henry is known to have travelled to France and Italy and possibly as far afield as Hungary, but certainly you see him here

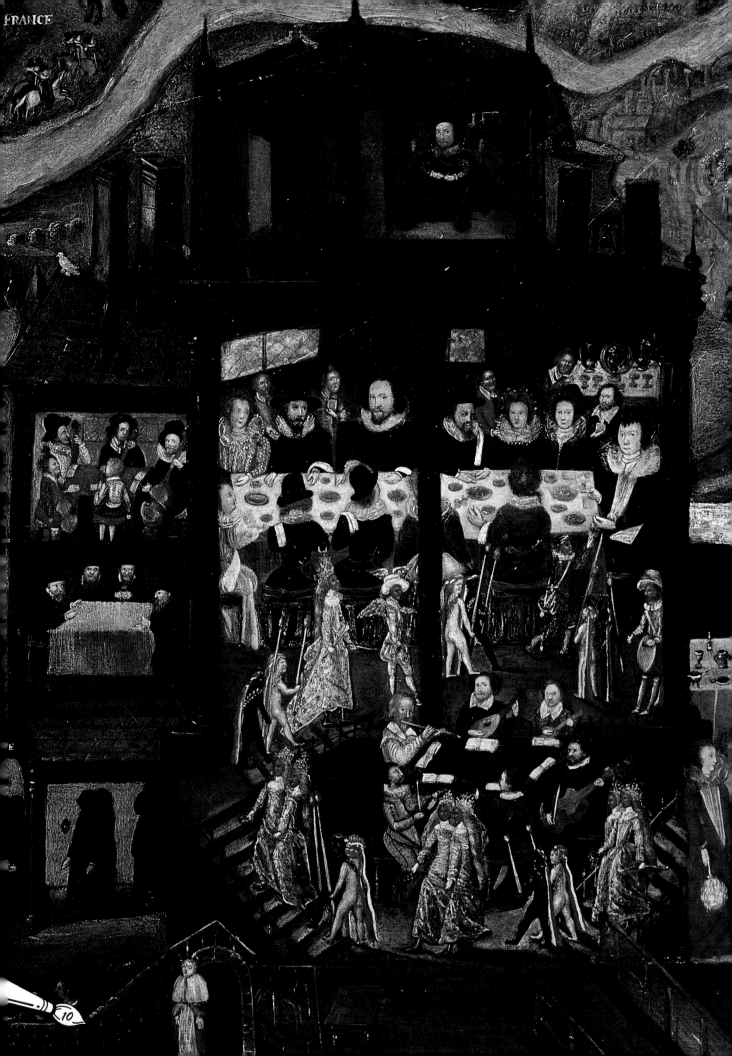

FRANCE

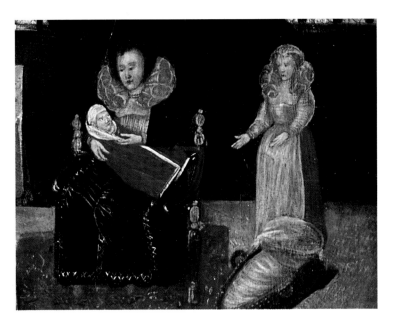

Detail

ABOVE: Sir Henry as a babe-in-arms about to be handed from mother to nurse.
LEFT: The ancestral home of Sir Henry, Wadley House in Berkshire, is the scene for study, music-making, discussions and lavish banquets.

travelling on horseback to Venice and Padua. Look at the great representation of the Alps jutting up just next to the sun in the top right-hand corner. He probably also studied at the University in Padua because he was known to be fluent in Italian.

He next moves into the Netherlands and you see him there in front of a tent. In 1585 he accompanied Robert Dudley, Earl of Leicester, on an expedition for Queen Elizabeth I. Certain provinces in the Netherlands were in revolt against King Philip II of Spain who was then their ruler, and the English Queen Elizabeth had sided herself against Philip. This was the time when Sir Henry was knighted after doing very well in the battle of Zutphen, against the Spanish in 1586.

Unton returned to England to the life of a country gentleman. In 1591 and 1595 he was sent as ambassador to France (see the scene next to the one top left). There was civil war going on in France. Philip II of Spain and the Catholic League had at first refused to recognize the Protestant Huguenot King, Henry IV, as the rightful King of France. We see Sir Henry on his horse riding towards King Henry's encampment to try and restore the alliance between Elizabeth and the French King when Henry was about to make up with Philip.

Misfortune befell Sir Henry at this point in his life, as he had a bad fall from his horse. He subsequently caught a fever, which had also decimated the troops, and despite the ministrations of the King's physician (seen in the red square section with Unton in bed and doctors everywhere), he eventually died. You can see directly below that picture the tiny ship with black sails that took his body across the Channel, then the black clad horses pulling the hearse. You can also see the poor and disabled people sitting lamenting under the white banners, as Unton was renowned for his charity work.

Right across the bottom of the painting runs the marvellously painted funeral procession. Doesn't it give a solemn sense of sadness and slow-moving dignity? It leads right across to Faringdon Church, which is packed with mourners. At the left you have an elaborate representation of Unton's funerary monument showing his widow, pale and sad, standing above a sculpture of Sir Henry lying in repose.

Let your eyes jump back to the dark central section on the right-hand side of the painting. This shows the private side of the man's life. The building is his ancestral home, Wadley House, in Berkshire. That's Unton in his study at the top, and the two scenes on the left show Unton playing the viola as part of a group of musicians accompanying a boy singer, and below that, conversing with some learned men. The largest scene in the house represents a banquet presided over by Sir Henry and his wife, Dorothy Wroughton. The guests are being entertained by a masque showing Mercury, messenger of the gods, and Diana the huntress, goddess of the moon. There are torch-bearers, maidens carrying bows and arrows, a group of musicians seated, and a standing drummer. Presumably the people seated around the table are recognisable portraits of the guests, and you will notice that the casual viewer of the painting is left in no doubt as to which are the host and hostess. Unton and his wife are portrayed as considerably bigger figures than all the rest at the table.

Just to complete the whole thing, I think I should point out that the sun on the right and the moon on the left indicate the passage from right to left, from birth through life to death. It is a truly delightful painting and a quite remarkable record of Sir Henry's life. It is a pity that the name of the artist has not also come down to us.

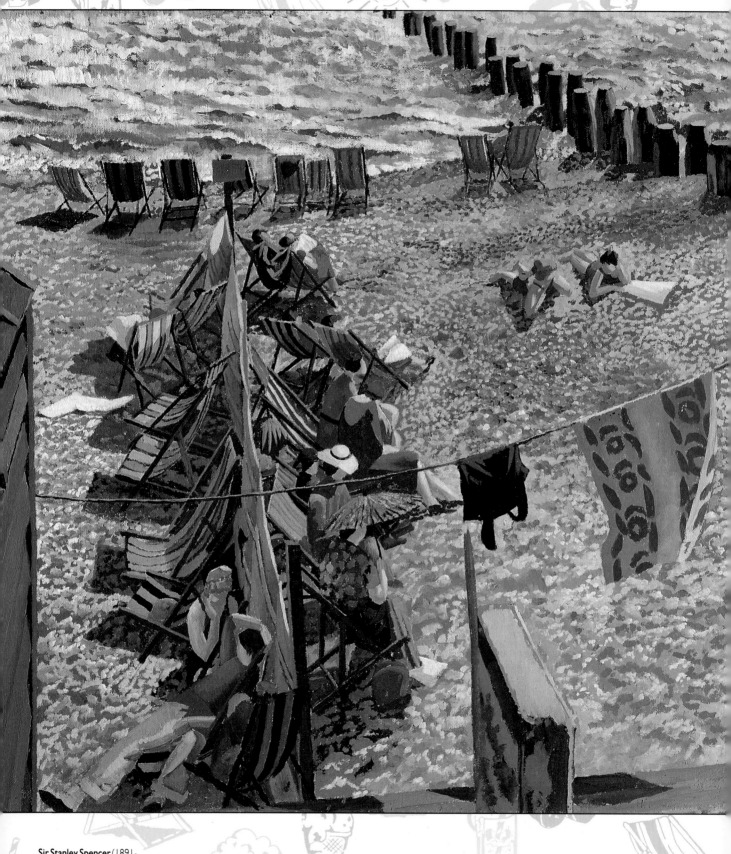

Sir Stanley Spencer (1891-1951). *Southwold*. 1937. Oil on canvas, 32 × 20 in. (81 × 50.8 cm.). Aberdeen Art Gallery and Museums.

SOUTHWOLD

OOH
AH
ETC

13

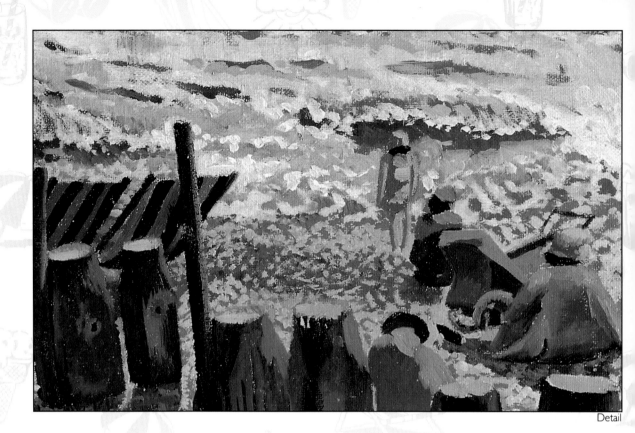

On first coming from Australia to England in 1952, I went to look up as many relatives as I could, travelling as far afield as Wales, and on one memorable occasion going to Budleigh Salterton in Devon. There was a lovely stretch of beach very reminiscent of this painting, I remember, and there were towels drying, deck-chairs spread out and, it seemed to me, remarkably few people actually swimming.

Now I hadn't been much of a sea swimmer in Australia due to the fact that we lived on the banks of a river miles from the sea. I grew up swimming in warm and peaceful water, no waves, and fresh water, not salt. The first time I had ever gone to swim in the sea with my parents, I recall I was almost eight and we had hired a six-foot-long surf board. I was a very good swimmer. I had been swimming at every available moment since I was about three years old, and thought I was the ants pants and knew everything there was to know about it. Well, you can see it coming can't you? I was great in river water, but knew nothing about being thrown about by waves and dragged here and there by undertow in sea

conditions. I had seen people flashing in on surf-boards so I decided it was easy, but I should try it in shallow water first.

If anyone had thought to tell me any rules about approaching the sea, I guess the first one would have been 'Don't turn your back on the waves'. But no one said 'Silly', as I stood waist deep, adjusting this six feet of floating mayhem so that it was snug, with the blunt end tucked in to my tummy, and my back to the huge sweep of the Indian Ocean. Somehow, the surf board had got under water, and I was reaching out with arms at full stretch trying to drag the pointed front end of this board free so that it would float on the surface, when suddenly the wave hit me square in the middle of the back.

It must have been spectacular to watch. The board nosedived, the point stuck in the sand and became the fulcrum of a six foot lever while I described a perfect arc taking all the thrust on my groin with the power of the ocean driving this whole diabolical machine. I don't know how far I travelled under water after I landed, but I can remember to this day the panic. I hadn't thought to breathe before the

14

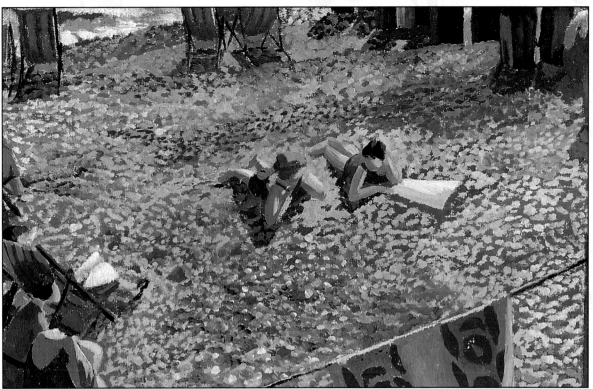

Detail

event and at no time did I know which way was up. I was buffeted and rolled and dumped and bumped and finally, as I knew I was dying through lack of oxygen, I fetched up with a jolt against a pole embedded in the sand. It didn't hurt. I was just so glad to have something to hang on to. As the stinging salt water receded, I opened my eyes to discover that I was climbing up some very surprised fellow's leg.

So that was my first experience of salt-water swimming. As you can imagine, I entertained no further desire to go anywhere near the sea.

Now let us leap-frog ahead to Budleigh Salterton beach and this brave twenty-two year old, intent on impressing his ageing relatives. Now that I think back, they must have been quite stunned when I insisted on changing at the house, and strolling barefoot the half-mile or so to the beach dressed only in a pair of bathing trunks, casually holding a towel.

Nobody seemed to be swimming. What was the matter with them? It was quite a mild day, not hot, but certainly not cold. I gave the towel to Uncle Arthur to hold and set off across the grass at breakneck speed towards the beach. No one had told me about pebble beaches. I guess I had travelled almost eight feet before I was totally crippled. I felt as if every bone in my feet were broken, dislocated, wrenched apart and strained, and the worst of it was I was going so fast that I couldn't slow down without mashing my feet totally. I did a low, running, racing dive into the waves which drew back as I approached.

If you've ever tried doing a dive onto a layer of moist pebbles, the smallest of them about the size of an orange, you'll know that it is not to be recommended. I lay there as the next wave engulfed me, and realized why there was no feeling in my feet any more (and why no one else was swimming!) The water was like ice! I lay there in a state of suspended animation – too cold to breathe in again. My heart had stopped…definitely…I knew that…I was just waiting for the last of the oxygen in my system to be used up before I was declared clinically dead.

What a dreadful picture it was…macho-man from Australia, skinned chest, bruised feet, blue with cold, being helped to hobble back to the house by two bemused old-age pensioners.

Thankfully, we all agreed that the whole episode should never be mentioned again, and it was only when I saw this picture that it flashed back to my mind to embarrass me all over again.

This painting by Sir Stanley Spencer captures the quality of light and the feeling of the seaside in England before the package holidays to Spain took over. As you see, one child stands contemplating paddling, and a couple are actually sunning themselves, but most of the people visible in the painting are content to sit at ease letting the sea air blow the city dust and cobwebs from their lungs.

It is such an evocative picture. You have to look twice to convince yourself that the towel hanging on the line isn't actually flapping, and as I looked away from the picture then I found myself almost shading my eyes against the sun.

SADAK

John Martin's painting *Sadak in Search of the Waters of Oblivion* is inspired by one of the *Tales of the Genii* by James Ridley. Published in 1762 it's a sort of *Arabian Nights* story in a different guise. The story, *Sadak and Kalasrade*, is of a Persian Nobleman called Sadak, whose wife Kalasrade has been carried off by the wicked Sultan. Briefly, the only way for Sadak to preserve Kalasrade's honour is for him to find the 'Waters of Oblivion' and bring some back to give to the Sultan.

This painting was the first major work done by John Martin, and he was only twenty-two years of age when he painted it. He loved to show people pitted against the elements, and later on he painted huge pictures on biblical themes showing mankind overwhelmed by the forces of God and nature.

You can see all this in the first painting; Sadak has reached the island in the Pacific and has almost scaled the cliff to get to the magical fountain. You can see the enormity of the track and the seemingly insurmountable and inhospitable jagged rock face, bare and bleak, that he still has to conquer. The painting actually depicts a moment in the story when Sadak has dropped off to sleep with exhaustion and nearly rolled off the rock ledge to his death. Somehow his fingers maintained a grip and he dragged himself back up onto the ledge. This time he wedged himself into a corner and despite the hammering of his heart, managed to fall asleep again.

John Martin (1789-1854).
Sadak in Search of the Waters of Oblivion. 1812.
Oil on canvas, 30 x 25 in.
(76.2 x 63.5 cm.).
Southampton Art Gallery and Museums.

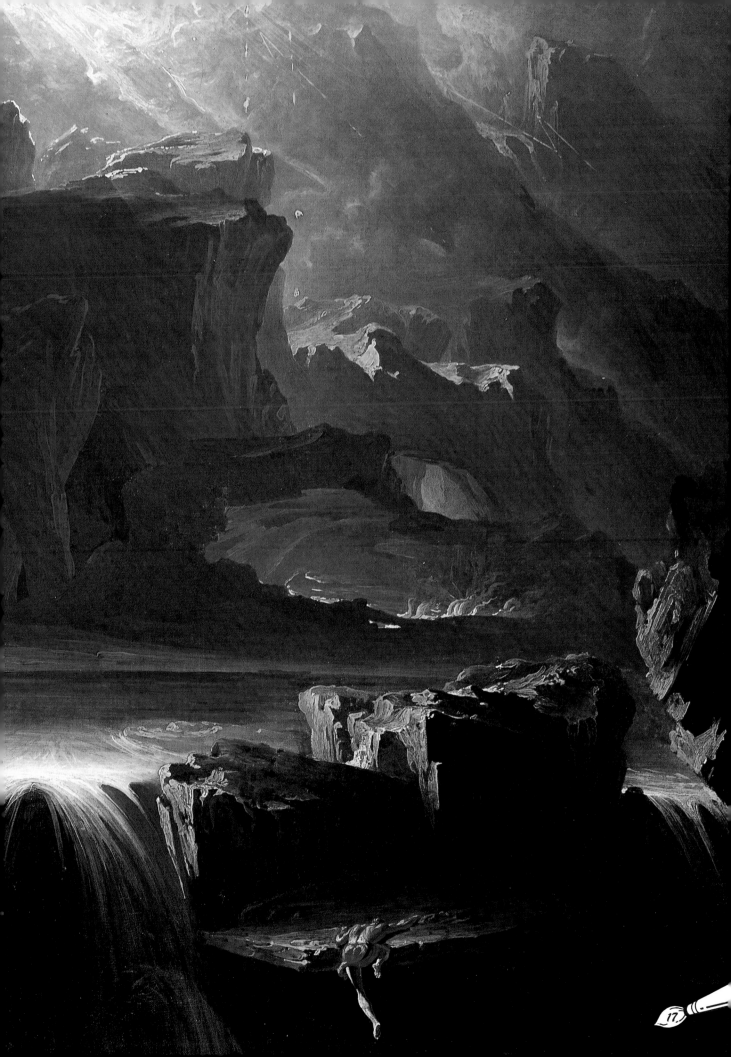

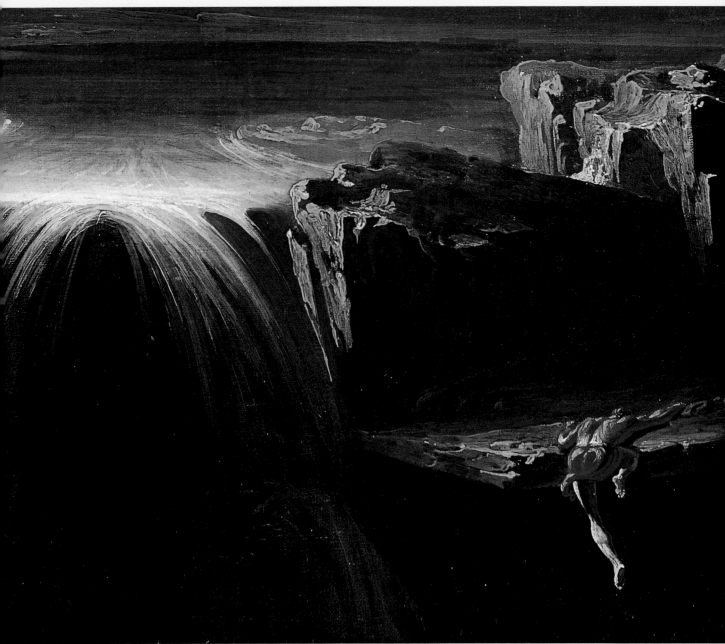

When he awoke it was to the darkness of night, broken only by the muted, flickering red light from the mouth of the volcano away to his right. That light concentrated his attention amazingly. He could see clearly in silhouette the path he must take to get to the spring. But to see a path was one thing...to travel it was another! It took him the best part of the remaining night to reach the spring and fill his flask with the magic waters. Dawn found him retracing his steps, the vital bottle secured and stoppered at his waist.

Suffice it to say that he had no need of disguise when he returned. By the time he and his crew had fought back against prevailing winds to his home port in Persia he was completely unrecognisable as the young fighting nobleman who had set off all those years before. His bearded face was almost burnt black by the sun, and deeply lined. His clothes were in tatters, and it said much for his character that the crew of the small craft had remained loyal to his dream and stayed with him throughout his voyage.

Let me leap you forward in time to the moment when Sadak faced his enemy. He had let word spread in the right quarters that a penniless sailor, one Timmur Al Hassan (the name he had assumed), had in his possession a flask of the Waters of Oblivion. In no time at all he was found and seized by the Sultan's men and marched to the palace, the same

Detail

Sadak struggles to drag his exhausted body up on to the rock ledge. The quality of Martin's painting of the water as it swirls and thunders over the edge is exquisite, especially when you realize that he had no photographs to work from as they hadn't been invented yet!

palace that imprisoned his beloved wife, Kalasrade.

Ibn Ben Obadan could hardly contain himself.

'Is that it?' he snapped as Sadak stood before him, 'I *must* have it. What will you take for it?'

'I must buy, equip and crew a ship to return me to India', Sadak lied, and proceeded to name an enormous price.

'Done!' The Sultan clapped his hands and made a gesture with his whiskery chin. Two slaves dragged forward a heavy chest and the Sultan began counting out a veritable King's ransom in gold coins.

'Pity help you if it is not the real thing. I will personally let you know how unhappy you have made me.' He laughed nastily. 'Quickly – the flask!'

Even though he hated the man so much, Sadak could not help himself. 'You must drink sparingly of the magic waters Your Highness – legend has it that too much…'

'Silence!' roared the Sultan. 'Your new-found wealth does not give you the right to tell me…Ibn Ben Obadan…how to regulate my life. *Give – me – the – flask*!'

'So be it', murmured Sadak.

Sadak unstoppered the earthenware vessel and passed it to the attendant who in turn passed it to the Sultan.

'Guard me well you sons of dogs.' The Sultan cast his eyes towards the bodyguards, 'I will be in a dream state and *very* vulnerable', and so saying he lay back on his pillows, composed himself and took a heavy swallow from the bottle.

Everyone seemed to be holding their breath, but in no time at all a serene smile spread across the Sultan's features. His eyes were tightly closed, but the creases of worry across his brow seemed to be smoothed away as if by magic. Soon his eyeballs began to jerk and twitch as in a dream and the smile on his lips broadened. 'More'. The single word was so quietly spoken that few heard, let alone understood it. 'MORE!' This time there was a hint of iron behind the voice. The servant holding the flask jumped to hold it to the Sultan's lips. 'Sparingly!', Sadak cried, lurching to his feet, but the bodyguard seized and restrained him as the Sultan snatched the flask away and drained the contents in a single huge swallow.

Every eye was upon him as a hoarse cry of pleasure escaped his lips. His eyes flickered open for an instant but obviously saw nothing of the real world. The flask fell from his nerveless grasp to shatter on the marble floor. His fingers twitched and his mouth and eyes flew open to remain frozen in a fixed, happy, yet ghastly expression.

'I tried to warn him!' Sadak cried.

'You've killed our Master!' shouted the leader of the bodyguards, drawing his scimitar. There was a hiss of metal on metal as his men followed suit, all that is except one man who flung himself down to kiss Sadak's feet in gratefulness. Soon others followed suit, and before very long Sadak was pronounced a hero for killing the wicked Sultan. When Kalasrade was released and reunited with Sadak, a feast was prepared, and soon the Sultan was forgotten forever.

FOR PITY'S SAKE WAKE UP….. AND SOMEHOW CONTRIVE TO LOOK ABSOLUTELY TERRIFIED!

Houseless and Hungry

Sir Luke Fildes (1844-1927). *Applicants for Admission to a Casual Ward.* 1874. Oil on canvas, 54 x 96 in. (137.1 x 243.7 cm.). London. Royal Holloway and Bedford New College.

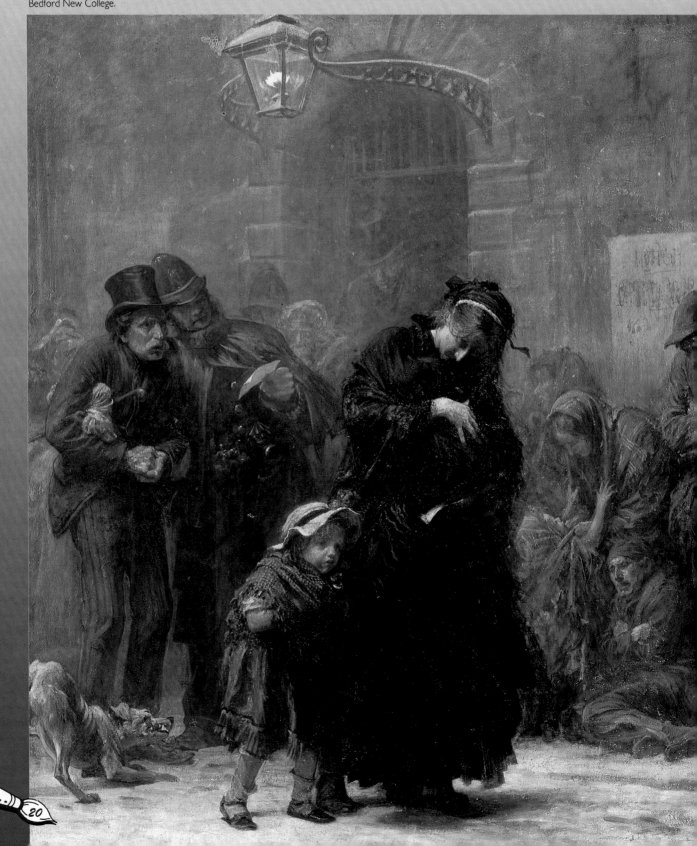

The Hansom cab clip-clopped around the corner and drew up in front of the building where the artist lived and had his studio. It was a dismal night, although not cold enough for more snow. 'Thank heaven for that!' he thought as he climbed down, slipped the driver the coins he had been clutching in his hand, and then quickly pulled his glove on again.

As the cab moved off he cursed himself for a fool. He should have got the key ready while he was in the comparative warmth of the cab.

He always thought he would be able to find it in his trouser pocket without removing his gloves, and invariably he was proved wrong. He held the glove between his left arm and his chest – slid his hand out of it and plunged into his trouser pocket for the key.

'More haste less speed', he could hear his mother's voice as the key slipped from his fingers and went clattering down on the cobbles. In his hurry to pick it up the glove fell into the slush of the street and he could feel his temper boiling up inside him. He

Fildes painted this picture from an earlier woodcut engraving based on a drawing he had done using real homeless people as models. Vincent van Gogh described the engraving as 'Superb'. See how many of the posters you can read.

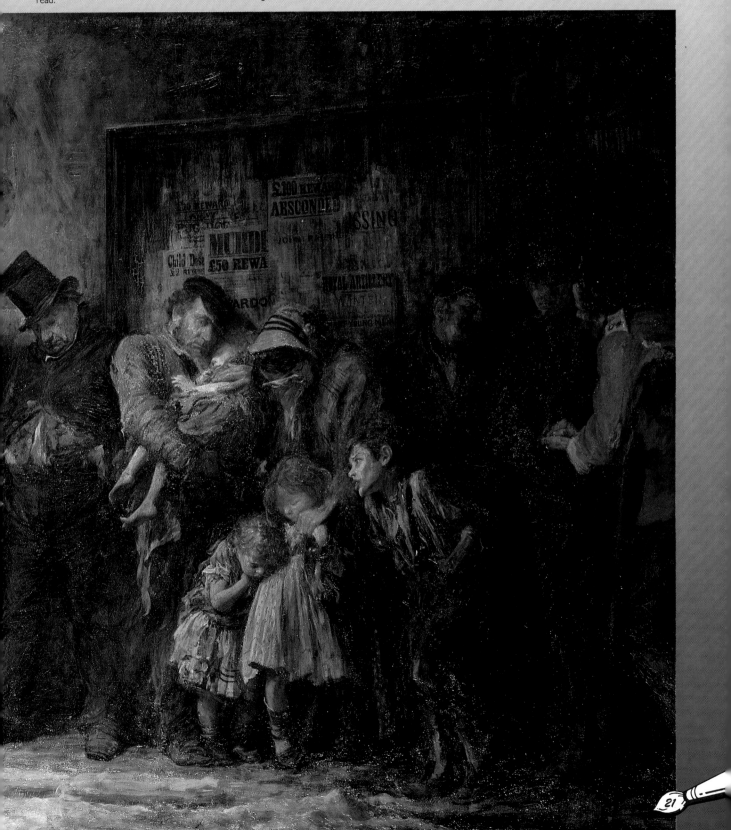

straightened up the wet glove and – key in hand – he turned to the door. In doing so, a slight movement in the dark of the doorway opposite caught his eye, and he turned back. With a shock he recognized the man from the police station. He had been passing there earlier that morning. A great crowd of down-and-outs were waiting in the cold to collect their tickets for spending the night in the poor house.

It was such a gloomy scene of despair, yet at the same time so visually exciting to the

man whose features had looked so good in the shadow cast by his hat rim.

'What is it?' he blurted out anxiously.

'If you're an artist I could come round and pose for you, for a small consideration.'

After a slightly awkward conversation, the artist passed on his address to the fellow and arranged for him to appear at ten in the morning as a model. And now here the man was in the middle of the night.

'I said ten in the morning,' he called across the road.

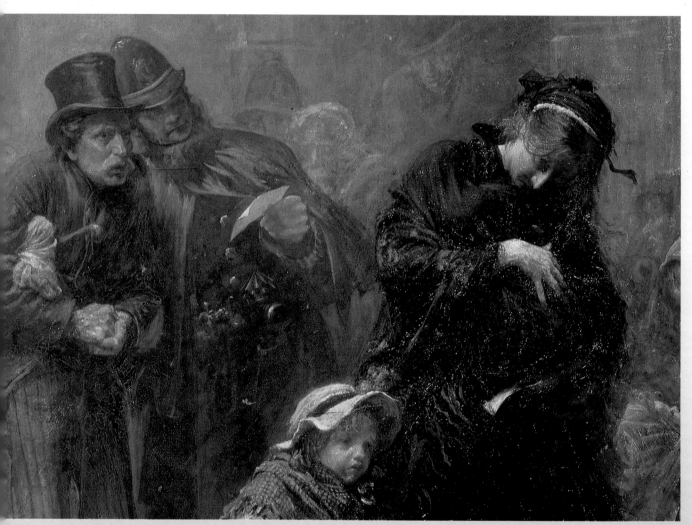

Detail

artist's eye, that he had brought out his ever-present sketch block. He noted the huddled forms and the amazing shapes made by a family group and couple; the shadows cast by an old hat across raddled features. Suddenly, a shout brought him back to reality.

'Clear off, toffee nose! Leave us alone in our misery. Think it's good fun do yer? Spend the night in the workhouse and think on it again!'

He looked up from his sketch block to meet such vitriolic hatred from a man cradling a small bare-footed child that he flushed scarlet, couldn't think of any decent thing to say, and turned in confusion and moved away. He tried to look as if it wasn't him at all, but someone else who had been doing the drawings.

'Ere, guv', a voice shouted after him.

He turned, and there was the top-hatted

'I know guv,' the man replied, moving out slightly from the doorway, 'but when I got back from talking to you this morning, they wouldn't let me in again, so I lost me spot and...well there's only so many places in the casual ward, and er...well, I wasn't lucky.'

'Well I've no room here,' he said hastily, fitting the key into the lock as fast as he could. 'I'll see you as arranged in the morning.'

'I could doss down anywhere...', began the fellow before the artist managed to get the door locked again from the inside. The nerve of the chap! Who knew what might happen? Social reform was all very well, but you couldn't just go inviting any Tom, Dick or Harry into your home...could end up robbed or even murdered.

His mind started to move on to more

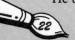

22

practical matters. The fellow hadn't looked or smelled all that clean. He would need some sheets of brown paper for the man to stand on, and in all probability a tin of that Keating's powder as a disinfectant to protect the carpet...

This picture, *Applicants for Admission to a Casual Ward*, painted in 1874, was based on a drawing done by Fildes several years earlier. The drawing was published in a periodical called *The Graphic* as a woodcut engraving

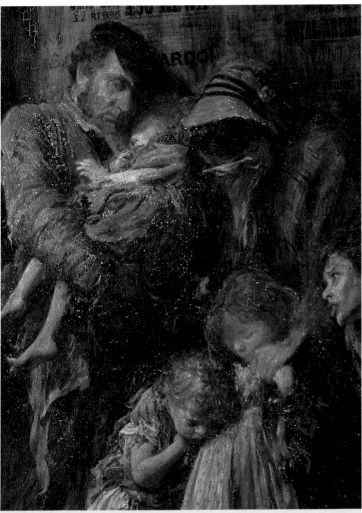

Detail

entitled *Houseless and Hungry*. Fildes used real down-and-outs for his models, inviting men, women and children he found wandering homeless in the streets to come back to his studio. There he would make detailed studies of them. He made many more studies than were ever used on the finished painting, and quite a few of these studies bear the names and addresses of the models. The top-hatted character in the middle of the picture, for example, was a certain George Mills of 46 Bedfordbury, Chandos Street, Charing Cross, and from what Fildes said, all he required by way of payment for posing was that the pint mug of strong drink be refilled every now and again by the pot-boy at the local pub.

When the wood engraving was published, it claimed to be an actual scene, rather than a composition done from posed studio sittings. Here's what was said: 'All these people, with many others, received tickets, and were admitted into the casual ward of one of our great workhouses a few minutes after this sketch was taken.'

The finished painting made a very strong comment on the society of the day, and the disgraceful conditions the poor had to put up with. The 'Wanted' posters on the wall in the painting are very revealing, in that they offer a £2 reward for a missing child, and £20 for a missing dog.

When the painting was exhibited at the Royal Academy of Art it caused a sensation. It was intended to stir the conscience of the Victorian public, and it did just that. A newspaper report said: 'Few men will turn away without long study of this mournful presentation of the debris of London life, and many will not fail to say "What can I do to better this state of things?" Morally and socially speaking, this is the picture of the year!'

An interesting side light on the picture is that the original engraving was one of those collected by the artist Vincent Van Gogh, who thought it 'superb'.

A LION HUNT

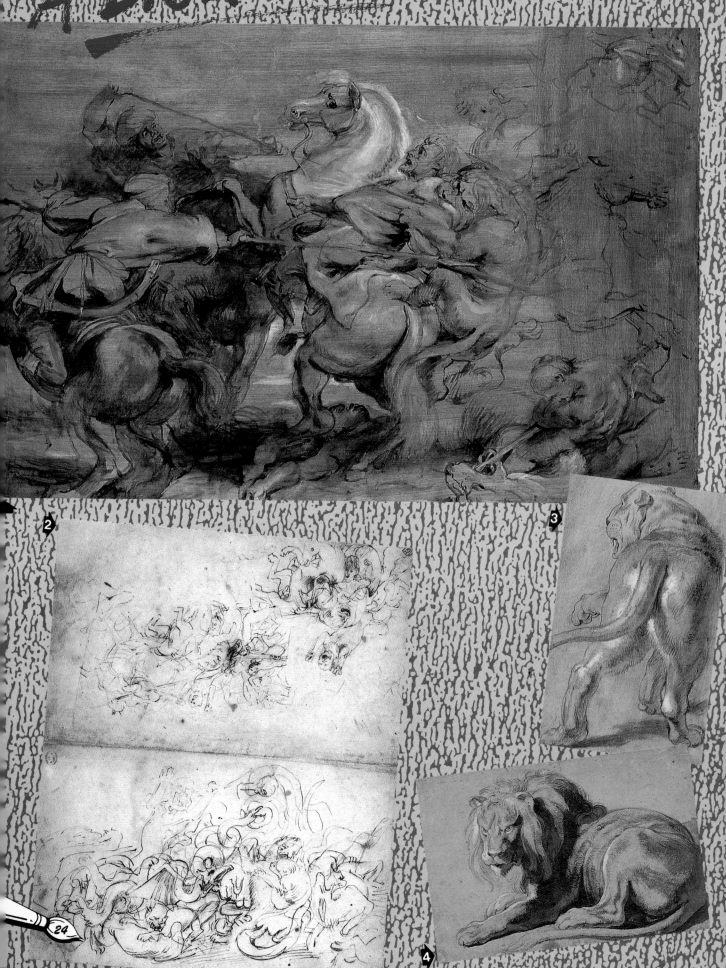

Peter Paul Rubens (1577-1640).
1: *A Lion Hunt.* 1615? Grisaille (grey drawing) oil on panel, 29 × 41½ in. (73.6 × 105.4 cm.). London, National Gallery.
2: *Large sheet of studies, with above, two studies for a lion hunt.* Pen and ink, 22½ × 19 in. (57.4 × 48.5 cm.). London, British Museum.
3: *A Lioness.* Chalk and wash heightened with bodycolour, 15½ × 9¼ in. (39.6 × 23.5 cm.). London, British Museum.
4: *A Seated Lion.* Chalk, wash and watercolour heightened with body-colour, 11 × 16¾ in. (28.1 × 42.7 cm.). London, British Museum.

When you look at the sketchy treatment of the Lion Hunt by Rubens and compare it to the heavy formality of the Battle of San Romano by Uccello (p.34) one thing strikes you immediately. In the battle scene with knights moving forward, lances being carefully brought into a ready position, the horses frozen in apparently posed groups, the whole thing seems to have the quality of a game of chess. You feel no thrill of fear or anger, no sense of danger, no inkling that the soldiers involved are going to lay about the enemy at fever pitch, cutting and hacking at them with the intention of killing as many as possible.

Now look from that cold composition to the swirling moving plunging shapes of the Rubens picture. You feel immediately that you've captured in the glimpse of an eye, one instant in an ongoing, changing, emotionally charged, moving, life and death struggle.

Peter Paul Rubens was a Flemish seventeenth-century painter who worked mostly in Amsterdam. He travelled extensively in Europe, but would never have seen, at first hand, such a lion hunt. One must marvel at his vivid imagination, his knowledge of anatomy, both human and animal, and the artistic skill that enabled him to capture the turmoil of this scene so vividly.

Look at the main character, eyes staring, left arm immobilized by the lion's paw and teeth, body dragged back by the lion's huge weight as he strives to drag a short sword from his belt with his right hand. His horse is rearing back in terror at the smell of the lion and in pain from the deeply imbedded claws of the animal.

Just enjoy the crisp, clean drawing of the horse galloping by in the opposite direction and the terrifically well seen action of the horseman as he holds the reins with one hand and swings his sword arm across his body, all the while measuring the lion with his eye for a cutting swing with the sword.

Just have a look up from there to the top right-hand corner of the picture. Rubens roughed out a little sketch of how he thought the main character and the lion might look, highlights and all, before he went ahead and painted them in fluent, swift strokes. You can see that lion, tightly sprung, powerful, vicious, lashing out at his tormentors in the only way he knows, while the two lances, apart from attacking him physically, skilfully direct your eye to the centre of the action. There is certainly no sensation of any of these men or animals being set in a fixed position or posed like chess pieces.

In the Europe of his time, lions and other exotic animals were collected and kept in special menageries by several European rulers and wealthy collectors, so Rubens would have been able to observe real lions in captivity. The seated lion was drawn from life but have a look at the strutting lioness drawing. This back view was drawn from a bronze sculpture he saw while travelling in Italy.

The page of studies here give you a further look at the way the man approached the composition of his paintings. He loved paintings involving writhing figures and animals and loved painting moving bodies in complicated twisted poses, rippling muscles very much in evidence.

The bottom sketch shows a convoluted serpent in the centre of some gigantic battle, obviously a rough thumb-nail sketch to explain the possible shapes he could create.

The top part of the page of sketches shows a couple of ideas for another lion hunt composition, but I think the page was folded across the middle and the top sketches were done up the other way. Turn the book upside-down and I think you'll agree that the lance-wielding horsemen, the horses and the lunging lions make more sense this way up.

The lion hunt, Rubens' unfinished oil sketch, was probably intended as a rough start from which his studio assistants would do all the donkey work of enlarging and painting in the background colours on a much larger canvas. The great man would then come in, fix anything that looked anatomically wrong, and do all the finishing of the work. This was the way some famous artists worked, and in some cases still work today.

Obviously this little panel of the lion hunt was never taken any further, as no large finished painting resembling it exists from Rubens.

I don't know what you feel, but I don't see how some huge finished oil painting could ever quite have captured the life and excitement that this small picture has. Perhaps we are better off just having this small painting.

HERE'S THE LAYOUT SKETCH LADS, MERRY CHRISTMAS TO YOU BOTH, I SHOULD BE BACK FROM ITALY END OF MAY SOME TIME TO ADD THE FINISHING TOUCHES!

How fascinating to see the different approaches of these two artists to what is basically the same subject, a train about to leave a busy railway station in the mid-nineteenth century. One station is in England and one in France, but this has little to do with the different approach of each artist.

William Powell Frith set out to do the traditional academic-style painting, every detail painstakingly put down on canvas only after exhaustive studies, sketches and compositional roughs had first been done. The station depicted is Paddington Station in London, which had been built earlier in the century as the terminus to serve the south west of England. Frith's desire for correct architectural detail was such that he engaged William Scott Morton, an artist who had originally trained as an architect, to paint all the top half of the painting, the arches, the supports, the intricate metal decorations, in fact everything apart from the train and the people.

This may sound like a bit of a cheat, to get someone else to paint half your picture for you, but it was apparently common practice at that time for important artists to call in specialists to paint in backgrounds or perhaps to add one or two figures where necessary.

I must say the architectural detail is exquisitely done. Paddington Station had been built using all the latest technology, with cast iron columns and girders, and a glass roof. This whole approach had been developed for the great Crystal Palace exhibition building, and even though the station had been repainted with a drab beige paint by the time Frith began his painting, he insisted that Morton paint the station the way it was originally, with the cast iron work picked out in bright contrasting colours. The fine iron tracery at the far end of the two arches is particularly well depicted.

What a contrast between the calm ordered organization of the building structure in the top of the picture, and the apparently disorganized bustle in the bottom half. Frith took a year and a half to complete his picture. It is hard in this day and age of instant video replay to imagine anyone devoting that much time to one picture, but when you look into the detail of the crowd you can see that there must have been an enormous amount of preparation done.

There are portraits of several well known people of the time included; in fact, the man who commissioned this painting, a prominent art dealer called Louis Victor Flatow wanted himself painted as the engine driver.
But the real engine driver refused point blank to allow the art dealer to pose in his engine. The outcome, as you can see, was that the driver is in his proper place, up in the cab of his beloved locomotive, and Flatow is the rather

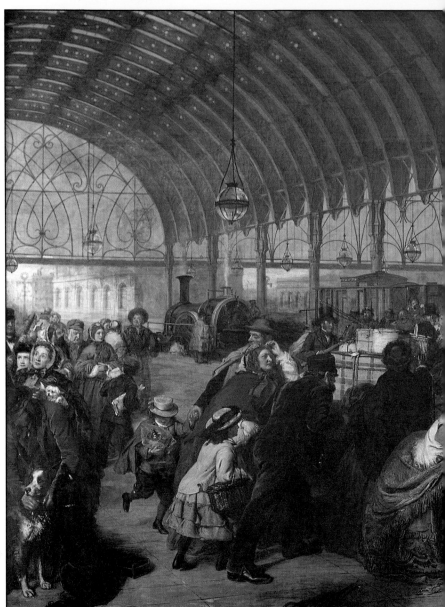

THE RAILWAY STATION AND GARE St LAZARE

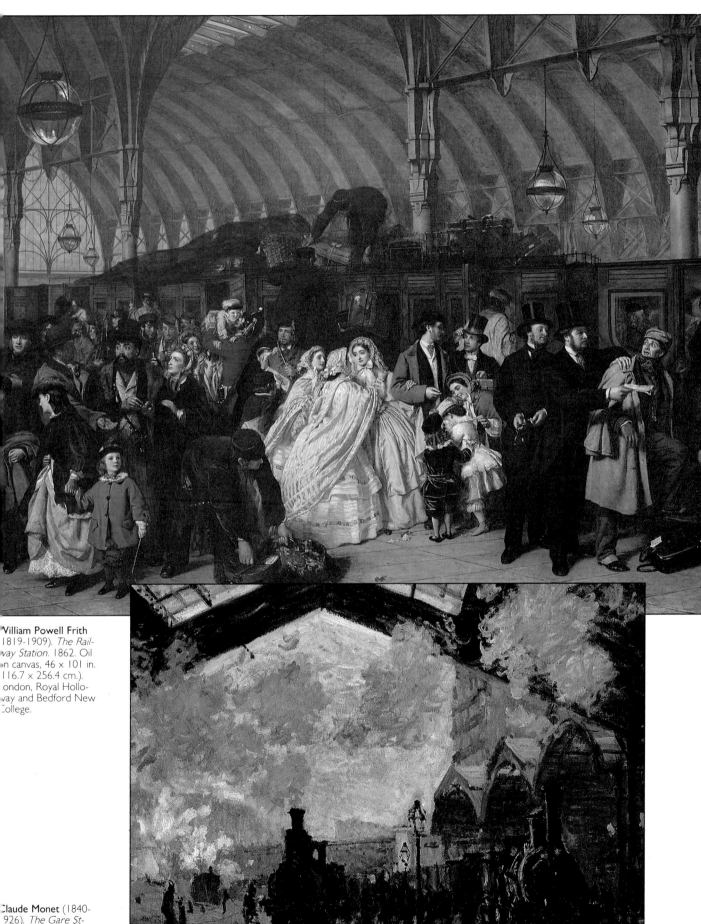

William Powell Frith
(1819-1909). *The Railway Station*. 1862. Oil on canvas, 46 × 101 in. (116.7 × 256.4 cm.). London, Royal Holloway and Bedford New College.

Claude Monet (1840-1926). *The Gare St-Lazare*. 1870? Oil on canvas, 21½ × 29 in. (54.3 × 73.6 cm.). London, National Gallery.

27

rotund man standing on the platform eagerly chatting to him.

In the centre foreground of the picture a mother kisses her young son goodbye, while the older brother stands very aloof and superior. Sister watches, holding the hand of a younger brother who gazes around at the wonders to be seen in every direction.

Right above the mother doing all that kissing is a group of three people, a man, woman and child. The man is a self-portrait by Frith, and the woman and child are in fact portraits of his own wife and child. He often used some of his children as models for his painting; he had twelve children by his first wife and a further seven by his second, so he had plenty of models to choose from.

The top-hatted bewhiskered gent in the centre, arguing with the cab driver over the fare, was a mysterious foreign gentleman from Venice who actually taught Italian to several of Frith's daughters. He posed on the understanding that Frith would disguise his looks, as he was afraid of being recognized!

The painting is a very faithful record of the people of the day who might be using the railway: a soldier (in red) lifts his small child up for a kiss; bridesmaids bid farewell to a new bride; newsboys, porters, luggage being piled on the roof of the carriage where a tarpaulin waits to cover the lot; it's all there,

even down to a pair of detectives arresting a criminal on the right of the picture. These two worthies were very recognizable as Detective Sergeant Michael Haydon (with the handcuffs), and the one with the warrant, Detective Sergeant James Brett.

Frith said they made great models as they were obviously used to staying still in one place waiting to catch criminals, and didn't seem to get bored with posing. There's one more recognizable portrait of a police officer. The man with the cap directly behind and to the right of top hatted 'foreign gentleman' was the then well-known Inspector Craig of the Great Western Police.

Now compare this incredibly detailed painting with Claude Monet's atmospheric look at the Gare St. Lazare. Frith's picture is almost like a beautifully lit action photograph, with every detail visible right down to the fly landing on the man's hat in the far distance, (well, nearly). Monet was intent on catching the mood and the feel of the 'moment'. You get the feeling that there are no lights at all in the station itself. The only light seems to be that from the sky at the far end of the arch. It filters through the puffs of smoke and steam from the locomotives, and the figures in silhouette are just suggested. You can vaguely see where the iron rails must be, although Monet did not consider them important

Detail

A mother kisses one of her four children goodbye, and a foreign gentleman argues with the cabbie over his fare, while in another part of the platform Detective Sergeants Haydon and Brett arrest a criminal.

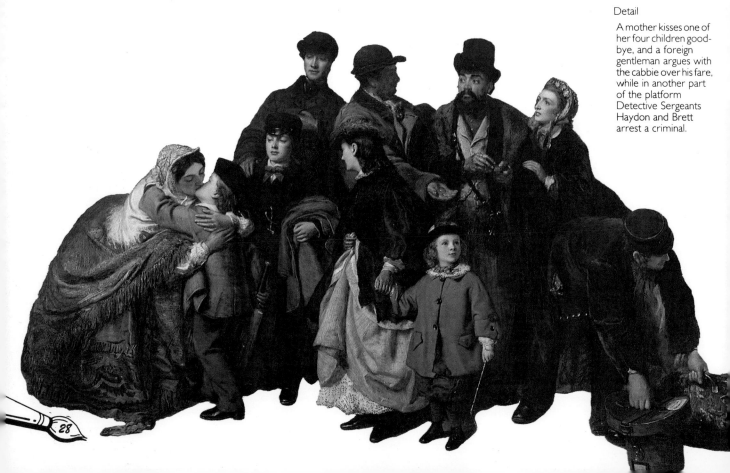

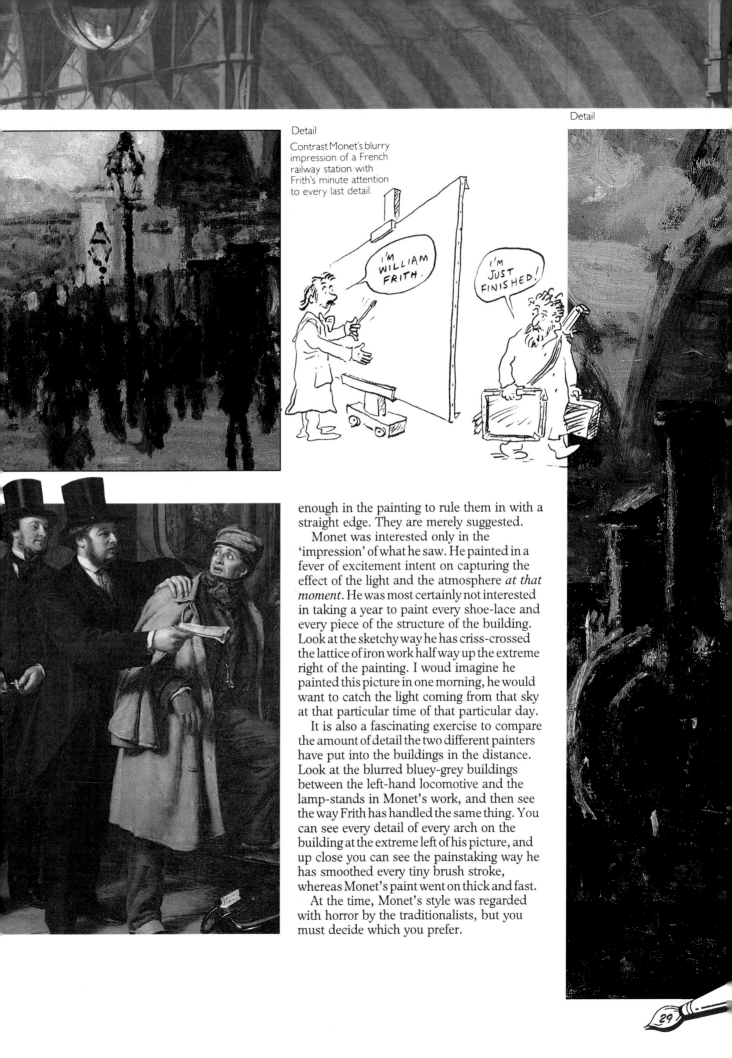

Contrast Monet's blurry
impression of a French
railway station with
Frith's minute attention
to every last detail.

I'M WILLIAM FRITH.

I'M JUST FINISHED!

enough in the painting to rule them in with a straight edge. They are merely suggested.

Monet was interested only in the 'impression' of what he saw. He painted in a fever of excitement intent on capturing the effect of the light and the atmosphere *at that moment*. He was most certainly not interested in taking a year to paint every shoe-lace and every piece of the structure of the building. Look at the sketchy way he has criss-crossed the lattice of iron work half way up the extreme right of the painting. I woud imagine he painted this picture in one morning, he would want to catch the light coming from that sky at that particular time of that particular day.

It is also a fascinating exercise to compare the amount of detail the two different painters have put into the buildings in the distance. Look at the blurred bluey-grey buildings between the left-hand locomotive and the lamp-stands in Monet's work, and then see the way Frith has handled the same thing. You can see every detail of every arch on the building at the extreme left of his picture, and up close you can see the painstaking way he has smoothed every tiny brush stroke, whereas Monet's paint went on thick and fast.

At the time, Monet's style was regarded with horror by the traditionalists, but you must decide which you prefer.

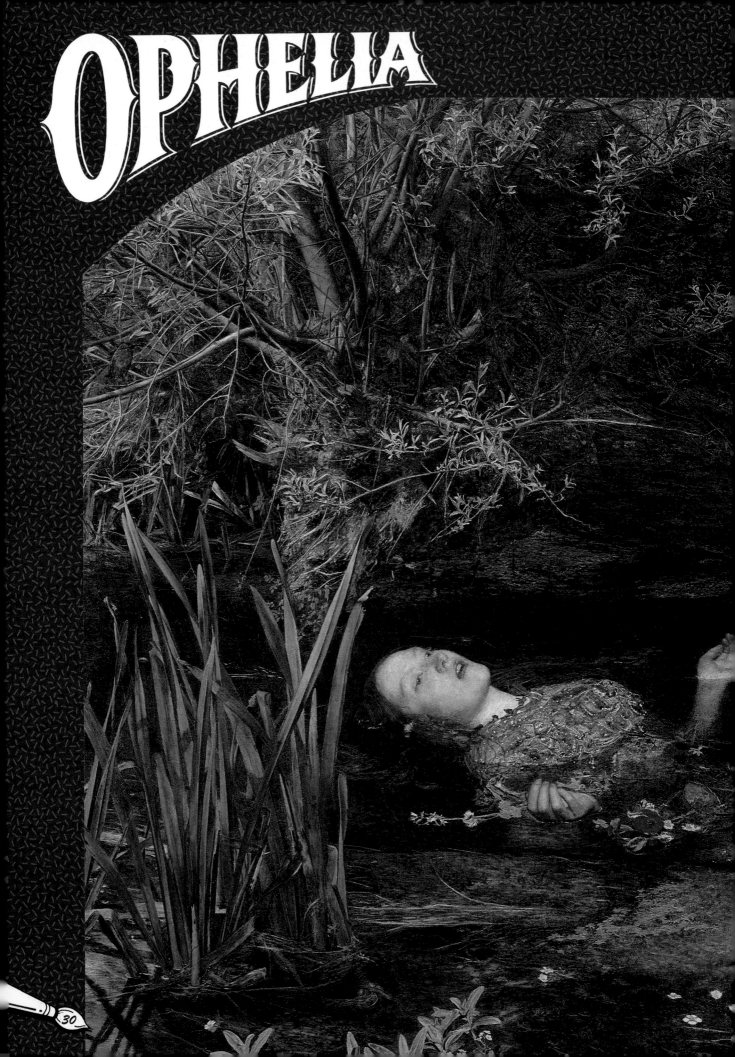

OPHELIA

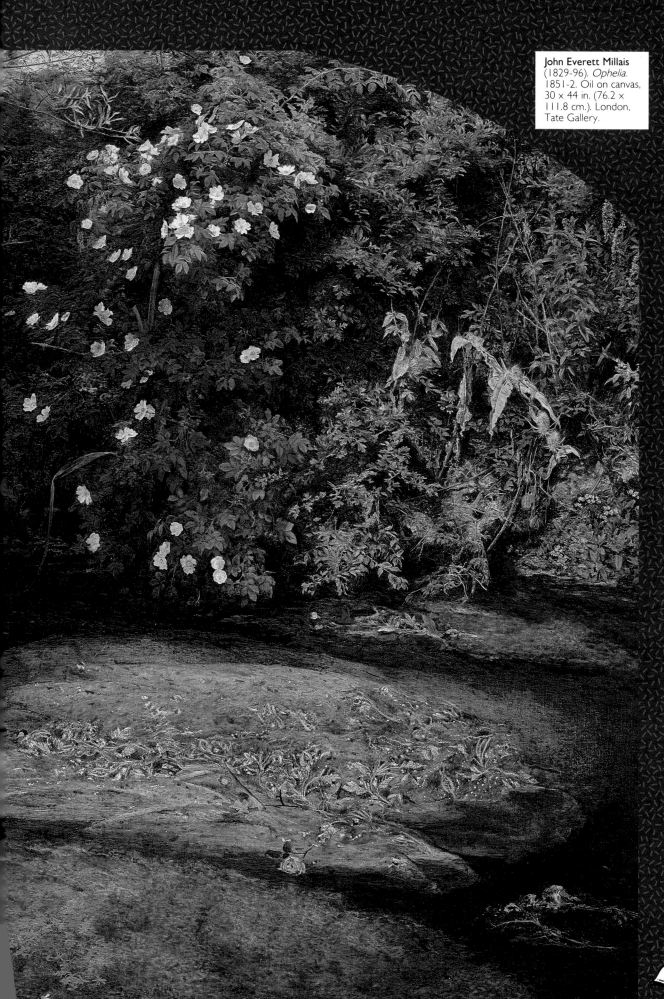

John Everett Millais
(1829-96). *Ophelia.*
1851-2. Oil on canvas,
30 x 44 in. (76.2 x
111.8 cm.). London,
Tate Gallery.

OPHELIA

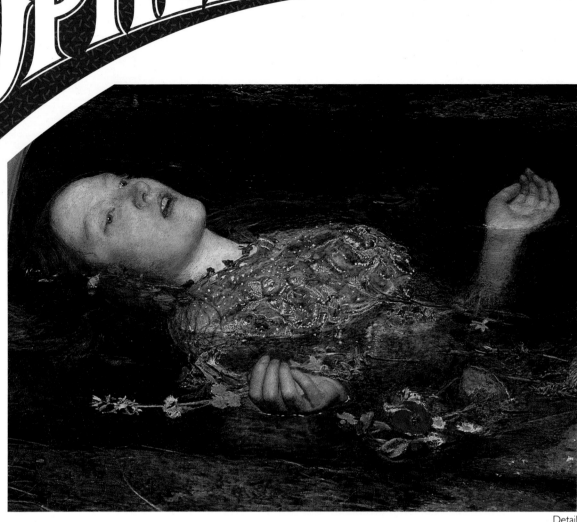

Detail

I first saw a reproduction of this painting when I was a small boy living in Australia. I was a very keen swimmer at that time, and it's funny the things that stick in your mind. I assumed, looking at the picture, that she was practising floating on her back. I can remember having two distinct reactions. The first was, she should tip her head back further, otherwise her feet would start to sink. The second reaction was, I'll bet her ears have filled up with water, and I could almost hear the bubbles of air escaping as the water flowed in.

I was so at ease in the water myself that it never occurred to me that she was in danger of losing her life. Perhaps it was the calm relaxed look on the face of the girl that helped give me that feeling of well being.

It is a most skilful painting. Do you know the story? Ophelia is a character from Shakespeare's play *Hamlet, Prince of Denmark*. Hamlet was in love with Ophelia, but was so obsessed with getting revenge on the uncle who had murdered his father that he pretended to be mad. This madness was part of a plan which misfired as far as Ophelia was concerned. She thought that his love for

her had turned to hatred, and later, when Hamlet killed her father, the Lord Chamberlain, her mind snapped. She was suddenly like a grown woman with the mind of a little child. While gathering flowers by the side of a brook one day, she fell in and was drowned, dragged under by the weight of the waterlogged dress she was wearing.

In the play, Hamlet's mother, the Queen, describes how Ophelia collected a garland of crow flowers, nettles, and daisies, and while clambering out on a branch to hang them on a tree, she fell into the brook below. Her clothes spread out and kept her floating for a while, and she, quite unaware of the danger she was in, sang snatches of old songs. Eventually her clothes became heavy with water and pulled her down to a muddy death.

The painter captures this feeling beautifully – the fact that Ophelia is unaware of any approaching disaster. You can almost hear the childish words of the song, and she has a vacant, faraway look in her eyes. The casual, relaxed pose of the hands also shows that she is completely at ease.

The painting of this picture took a long time and was done in two parts. Millais included many of the flowers and plants mentioned in the play, quite a few of which symbolized special things at that time. The pansies seen floating in the water mean both thought and love in vain. The chain of violets around Ophelia's neck refer to a line Ophelia says in the play about the violets that 'withered all, when my father died'. Violets, to the Victorians, symbolized faith, chastity, and death of the young. There are roses in the picture, which refer to Ophelia's brother Laertes, calling her a 'Rose of May'.

Millais chose all sorts of other plants not mentioned in the play for their symbolism. Poppies you can find, they symbolized death; meadowsweet meant uselessness; pheasant's eye and fritillary, the spotted flowers floating between the dress and the water's edge, both meant sorrow.

All the plants are beautifully painted with great botanical accuracy, as was all the background. Everything except the figure was painted during the summer of 1851. Millais' friends, the Lemprière family, had a house near Ewell in Surrey, and there on the bank of the Hogsmill River, the artist worked every fine day for about three and a half months, painstakingly recording the scene.

When it came to painting the figure of Ophelia, Millais moved back to his studio, set up a bath full of water, and employed a model called Lizzy Siddal to pose for him. From what we can gather, she lay fully clothed in the water, daily for some four months, while he painstakingly recorded every detail of her face and hands. He specially bought an antique silver embroidered gown to depict in the painting.

It must have been a particularly unpleasant task. Every day she had to get back into the bath and lie with ears under water, and be prepared to stay there for most of the day, bored out of her mind by having to stay still with hands and face in a certain fixed position.

To keep her warm, Millais had lamps lighted under the bath, but such was the single-mindedness of the painter in him, that on several occasions the lamps went out unnoticed, the water got slowly colder, and the poor girl caught a severe cold. Her father had to threaten Millais with legal action before he would pay her doctor's bills.

When you look at the finished picture it is hard to believe that the two parts of the painting were done at different times, they are so skilfully married together. It is also hard to believe how anyone could have spent so much time and money on painting the one work.

The critic John Ruskin described it as 'The loveliest English landscape, haunted by sorrow.' I know *I* have remembered it since I was a child, long before I ever heard of Hamlet, or indeed, of Shakespeare.

33

Battle of San Romano

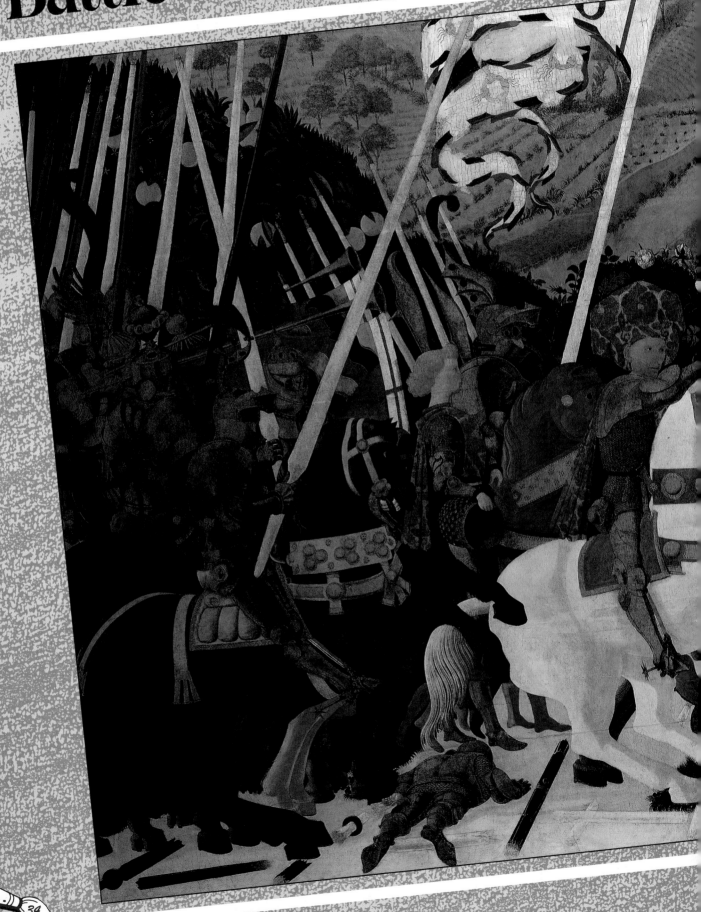

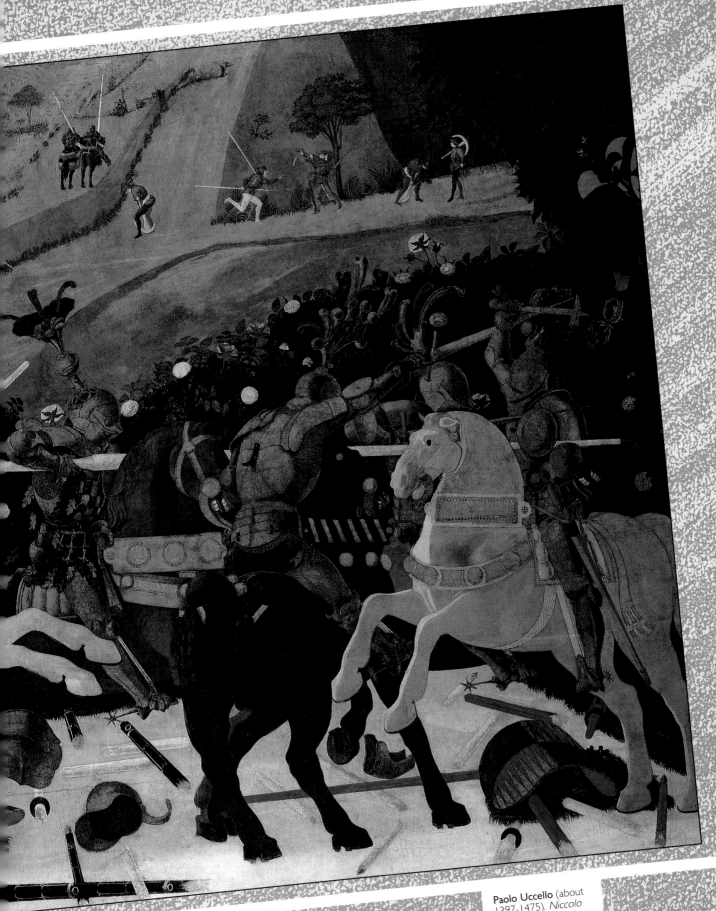

Paolo Uccello (about 1397-1475). *Niccolo Mauruzi da Tolentino at the Battle of San Romano.* 1450s. Oil on panel, painted area 71½ × 126 in. (181.6 × 320 cm.). London, National Gallery.

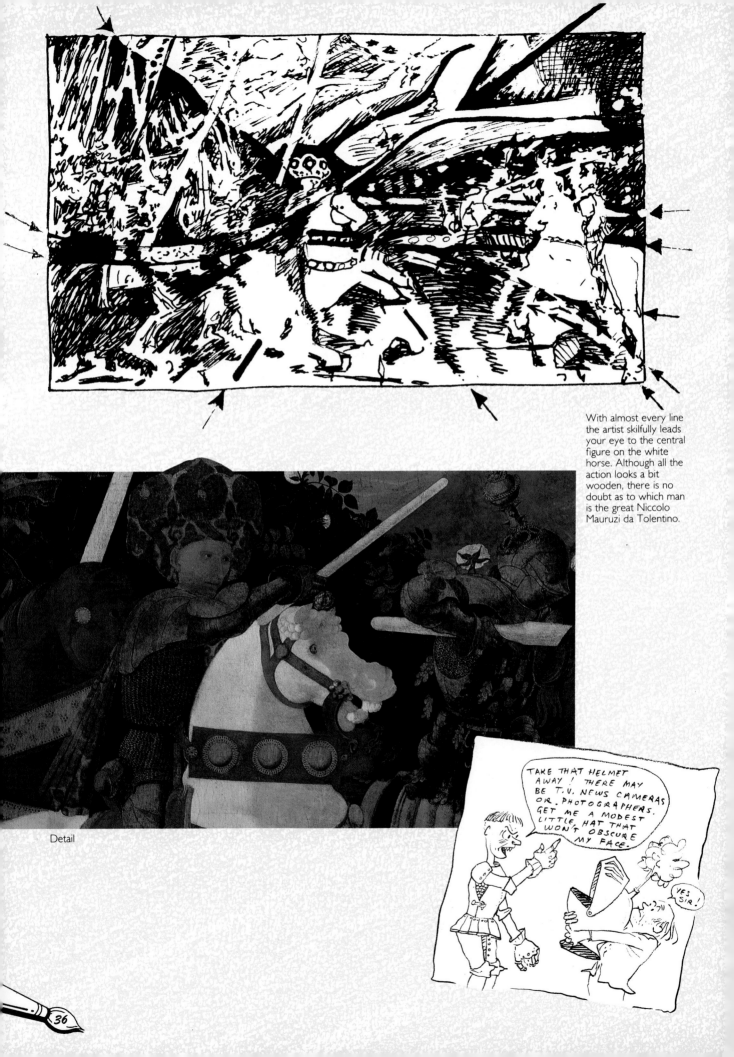

With almost every line the artist skilfully leads your eye to the central figure on the white horse. Although all the action looks a bit wooden, there is no doubt as to which man is the great Niccolo Mauruzi da Tolentino.

Detail

When you look at a picture, it is always interesting to know why it was painted. Let me set the scene for the painting of this picture. Italy…mid-fifteenth century…poor communications…slow travel…neighbouring cities fighting one another to try to gain supremacy.

In the north of Italy, in Tuscany, lies the city of Pisa where the famous leaning tower stands …or rather, leans. The cities of Lucca, Arezzo, Pistoia, Siena and Florence, all raised armies and fought one another to see who could be top dog in Tuscany. Not only that, but in each city there were various factions and families fighting and plotting against one another for control and power within that city. Such a family were the Medicis, the most powerful and wealthy banking family in Florence, and they effectively governed that city for several hundred years. In that time, as you can imagine, several fierce battles broke out between their city and the neighbouring Siena.

This painting is one of a series of panels that commemorate the Battle of San Romano which took place in 1432. Florence won on that occasion, and it is thought that perhaps the panels were painted for the Medicis, as

they certainly hung, at one time, in the family's city palace. The central character in the painting is the famous Florentine soldier Niccolo Mauruzi da Tolentino, who sits astride his white horse, sword in hand. All the other soldiers are wearing helmets, but Niccolo himself has on a huge, richly brocaded head-dress which leaves his face visible (so that we can have a decent, recognisable portrait of him, I presume).

To me, it is very interesting to see the way the painter Paolo Uccello, has focussed attention on the main figure. I've done a rough sketch of the painting, emphasizing the lines, both dark and light, so you can see a little more clearly, how carefully the artist leads your eyes from any point of the picture towards Niccolo sitting on his horse. In the middle there is even a dark sort of halo of leaves tight behind the figure which emphasizes his huge hat, and if you look up in the top right of the picture, there is a huge V shape, almost like a big arrow pointing straight in to his face. It is a very skilful painting I think you'll agree.

If you've ever tried to draw someone lying flat on the floor with their feet facing you, you know just how hard it is to get it to look right. The early painters had a clever method of drawing such difficult things as the fallen knight at the bottom left of the picture. Here's how they did it. They placed a sheet of thin paper or glass in a frame. Then they would set up their models in the right pose, and looking through the fixed frame they would draw on the paper exactly what they saw. It's a good idea isn't it, almost like tracing?

From these early beginnings artists learned how to draw figures in awkward poses and also how to draw buildings and landscape in perspective, with things appearing to get smaller as they got further away.

When you look at this battle picture as a whole, however, it looks a very formal and posed affair doesn't it? You somehow don't feel that any one of the combatants is even the least bit excited or intent on doing any harm or damage to anyone at all. They all somehow look as if they have been told to stand still in their positions while the artist did a detailed painting of them. Even the foot soldiers in the far distance look a bit wooden.

I understand that when painting horses they actually built scaffolding around each one to keep it steady in the rearing up position while it was copied on to the canvas.

It is thought that this battle painting once had a curved semi-circular top which fitted into an arch in the Medici palace. This means that the landscape and the sky of this painting would, at one time, have extended much further. Whatever the case, it certainly gives a fascinating view of what the Tuscan countryside must have looked like at the time.

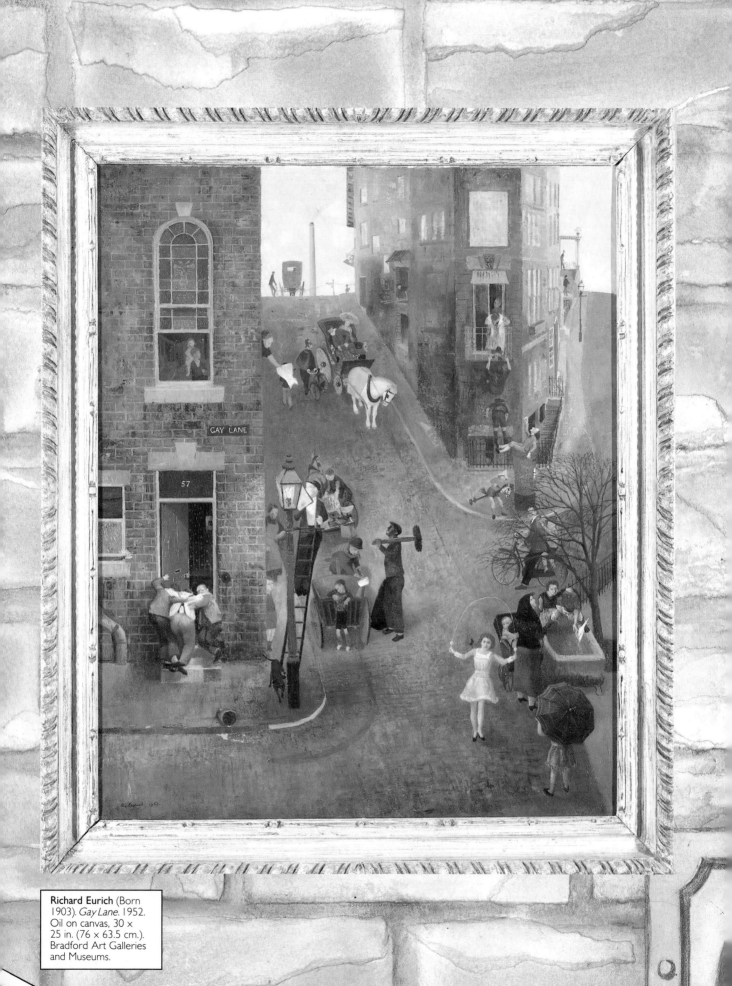

Richard Eurich (Born
1903). *Gay Lane*. 1952.
Oil on canvas, 30 ×
25 in. (76 × 63.5 cm.).
Bradford Art Galleries
and Museums.

38

GAY LANE

Richard Eurich was born and brought up in Bradford in Yorkshire, but moved to Ilkley when his mother's health demanded fresher air than was to be found in the polluted city of the early 1900s.

This fascinating painting, though it's supposed to be of Gay Lane in Ilkley, actually owes more to the memories he brought with him from Bradford. The street has been transformed into the steeply inclined, stone set, terraced streets that were to be found in any number of Yorkshire industrial towns.

Eurich has filled his painting with incidents and activities that would have occurred every day in any of these streets. This was painted in 1952 after the Second World War, and, as Eurich said, these images in my memory, like any number of small pencil sketches, 'can be so evocative of the time and place that a full scale painting can emerge that is truthful, but has some added depth that comes from living the past and the present together.'

I said at the outset that this painting has a fascination for me, and that fascination lies in the amazing difference between *his* childhood memories, and mine. The memories I had of *my* childhood were of unpaved 'dirt' roads in a totally undeveloped part of a suburb, seven miles out of the centre of Perth in Western Australia. My mother and father had mortgaged themselves to buy an acre and a quarter of land which had a river as one boundary. During the time when I was growing, from three and a half up to about twelve, my dad built, with his own hands, new

bits of the house, as and when he could afford it.

The climate, of course, made it a heavenly place for a lad to grow up in: winters quite wet, but not too cold; summers really hot, swimming and climbing trees at every spare moment. Magical! None of the kids in my class had shoes, and in fact I never owned a pair until I had to get them for high school when I was twelve. In winter my feet were pink and spotless due to the fact that the grass in the paddocks on the way to school was wet. In summer they were always filthy dirty, and the same colour as whatever dry soil you had been running through.

Contrast that with this marvellous painting of the densely populated, bustling street with a million things going on all the time, and everyone knowing every one else's business. It's a view of life I find hard to conjure up and as such, it is new and strangely exciting. To be able to run out of your front door and find twenty-odd kids within playing range would have been a totally amazing thing to me as a child.

'Hurry up and finish. Your Dad'll be home in a minute and you know he can't stand scales.'

Terry Gaunt gritted his teeth against his mother's shouted words from the kitchen.

'Amazing,' he thought, 'I didn't want to do it, me Da' hated the thought, and yet, just to spite me Aunty Dolly, here I am playing the piano.'

His mind went skating back to the trip two Christmases ago when they were all invited to Aunty Dolly's for a big meal. His cousin

Donald was sat down at the piano to show off his prowess. He had played dutifully through the first three pages of *Eight Little Pieces for Two Hands*, reading all those dots and things, and then Terry, a year younger and very much the uncouth lout in his Aunty's eyes, had pushed Donald along the piano stool, joined him and started playing in a totally untutored way, every note he could lay his hands on... total discord!

He could feel the atmosphere even now. His mother's expression changing from indulgent smile to the outraged amazement as Aunty

Dolly forcibly removed his hands from the keys, closed the lid and actually locked the piano, removing the key. The two families looked on, stunned.

He personally couldn't have cared less, didn't mind being stopped as long as the show-off Donald was stopped too. But his Mam couldn't leave it alone. All the way home she carried on to his father about it. 'She thinks she's so high and mighty', and 'How dare she lay her hands on our Terence', followed later by 'She thinks she's the only one who can afford a piano.'

Now here he was, nearly a year into lessons with Mr Tompkinson, lessons which his Mam kept reminding him they could ill afford, and the amazing thing was, he was good at it. Mr Tompkinson said he had a good ear and he had to confess, he loved being able to read and make sense of the hieroglyphics and actually play what was written. All the rows they had had while his Mam was searching for a second-hand piano. 'We'll find the money somehow,' she said over and over.

Now the dreaded piano standing in the front room seemed to have taken on the role of the 'enemy' as far as his Dad was concerned. No mention was made of it in his father's hearing, and his practice had to be done before his Dad got back from the pit. He left the piano and was out of the room, door closed, before his father was actually in the house.

'Can I borrow the bike Dad?' he said. 'I'll be careful.'

'Alright son, see you do. Is me bath ready?'

'I should think so Dad, Mam's in the kitchen.' He didn't wait to watch the ritual of the bath. He would doubtless be trapped into scrubbing his Dad's back and it always made him embarrassed, his Dad's nakedness and everything, the filthy black water from the coal and the white limbs and knobbly knees sticking out. His Dad's jokes were the worst part because he didn't understand them and had to pretend he did. His Dad thought piano playing was 'sissy' and tried to introduce rough tough man's talk at every opportunity; it only embarrassed Terry. He had enough of that sort of talk with his mates up and down the lane, didn't need it from his Dad too!

He was out of the house. It was like a magic other world. Davey Hardacre came running across from the pillarbox and no word was needed as they pushed the bike up to the top of the hill. They both nodded to old Mr Soames and the lad. It was hard to know where to look as the painfully thin boy strapped into the makeshift pram waved his arms and rolled his head, eyes rolling. His old grandfather pushed him all over the town in that thing. 'Hello Laurie,' Davey called as they passed. The boy seemed to smile even more. You never knew how much he understood.

They crossed the road to avoid the trio of drunks who staggered and slipped down their side of the pavement. They wondered where old Spilsby got the money to get that rotten every night. His two mates always had to help drag him home. He'd left his coat somewhere too. It was more than the rest of the day was worth to tell them. You'd finish up trapped in a drunken conversation for hours, and like as not have to go off on the bike to retrieve the coat for him.

They got to the brow of the hill and in a well practised manoeuvre Davey hopped up on the seat and Terry straddled the bar, and standing on the pedals went careering off as fast as he could go. Kids scattered everywhere as they shot down the hill like a bolt of greased lightning, Terry pedalling and Davey yelling past his ear at Denise Nuttall, who was somehow using up the whole of the street with her skipping rope.

'Hey nuts! Nutty...shift yourself!' Davey shouted. 'Look out!'

There was no room to get between her and the trough, and now the three old crows in black had turned and were watching with staring eyes.

Her little sister Cynthia stopped twirling her umbrella and got Denise to move just in time, and they did a glorious stopping skid on the greasy road at the bottom. Davey finished up on hands and knees laughing like a lunatic, and Terry looked around with a great smile on his face as if expecting applause from everyone in the street. As he turned to look back up the hill his heart sank. P.C. Dennison, the 'Long Arm of the Law' as they called him, was free-wheeling down the hill. Terry tried to look as if he'd just sauntered round the corner and found the bike, but his act did no good at all. 'Young Gaunt isn't it?'

It wasn't a question requiring an answer, you just stood and waited for the next bit.

'I catch you riding your Dad's bike down this hill with someone on the seat again I'll give you a clip round the ear. Do you want me to talk to your father?'

'No sir,' Terry mumbled. Davey was looking the other way trying to pretend it had nothing to do with him.

'Right...take the bike inside and find something else to play at.'

It was over. The constable wheeled his bike away around the corner, nodding to Mrs Jenkins and the chimney sweep fellow who were trying to agree a price, and Terry sneaked his father's bike round to the jitty and in the back gate.

He was just putting the bike away safely in the coal shed when his mother's face appeared at the window.

'Good,' she said, 'save me coming to fetch you. Take this and get us some cod and chips. Your father fancies that for his tea.' She held out some money.

'But Ma, Davey and I were just going to play with our whipping tops...'

'Do you want me to get your father to you?'

'No Ma.'

Davey hung over the fence looking blank, while Terry with very bad grace dragged the bike out again and set off to get the evening meal.

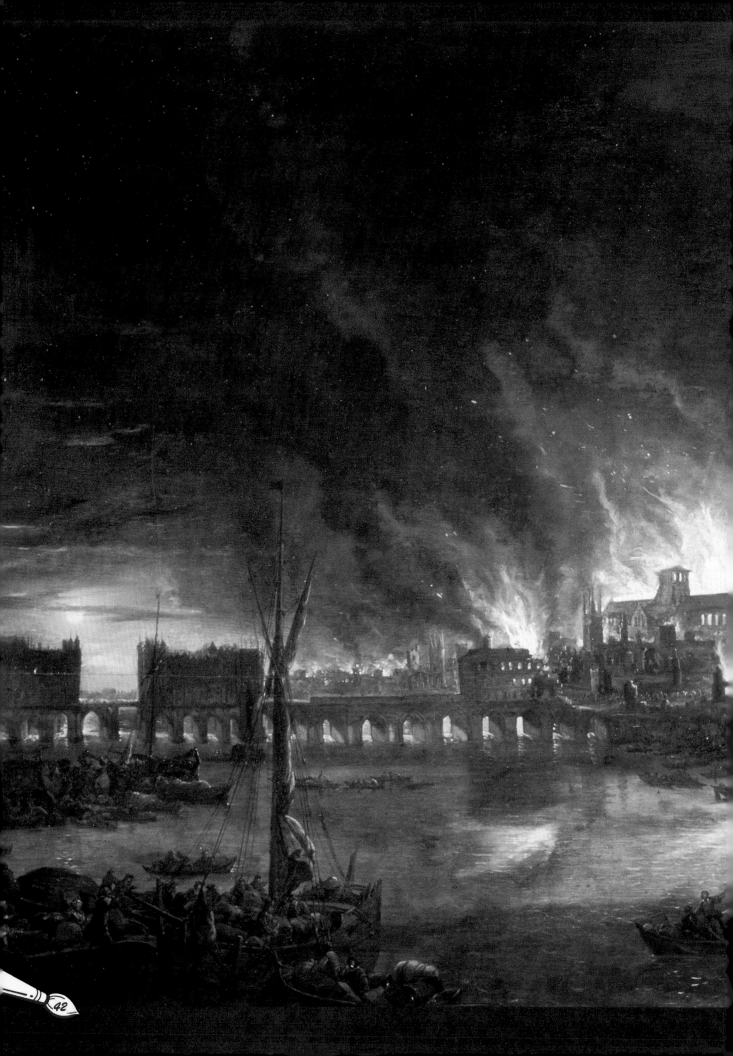

The Fire of London

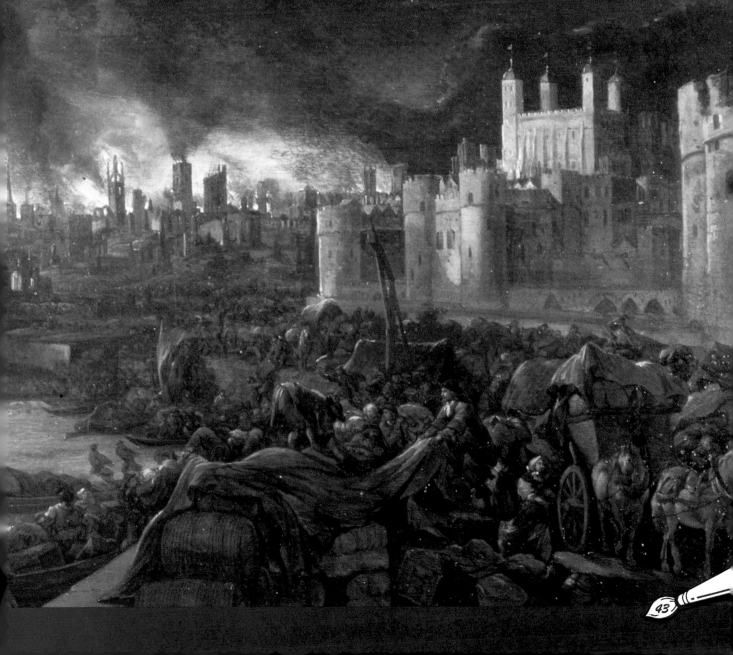

There was no fear in his heart as he carefully picked his way down the darkened staircase. He knew every step, knew where to stay close to the wall to avoid a particularly creaky floorboard, knew which steps were a slightly different height, knew it all.

By now he was well away from his parents' bedchamber, and with the servants on the floor above that, he knew he was safe. He stopped the tip-toe creeping and, holding the banister, walked normally down the remaining stairs as if it were broad daylight. As soon as he got to the bakery he would find the precious tinder-box, light up his candle and survey his 'domain'.

There was no doubt about it, he, Frederick Thomas Farrinor, was going to be the most famous of bakers when he grew up. He already knew everything there was to know about making the fancy sweet breads and confection that the King liked so much, and sometimes his father actually let him do the decoration on the tops of the cakes.

He paused in his thoughts while he negotiated the awkward latch, and finally the door was opened. He felt his way around the room to the stool which always stood in the little alcove. He put his candle in its holder on the floor, and with a great effort, lifted the heavy stool and carried it to the cupboard. In a moment he had climbed up to kneel on the stool and feel on the shelf for the magic tinder-box. He still thought of it as magic, even though he was a big boy now, and he knew better. Well…it *was* magic…the way a tiny spark from the flint could eventually turn into a fire big enough to cook all the bread in the whole bakery.

He found the tinder-box pushed right back in its usual place, and as soon as he could manage it he was back kneeling in front of his candle, coaxing the magic spark that would light up the whole of his special playground.

There…at last, it was done. He held the candle up high so the light wouldn't shine directly into his eyes and looked lovingly at all the marvellous bits and pieces that made up the King's bakery.

The first thing he was shocked to notice was that the fire door was open. The fire door at the base of the oven was NEVER left open. He knew that. The only time he could remember his father beating him was when he had tried to open that very same door. Of course he had burnt his fingers on the metal handle and it was his crying that had really got him into trouble. If he hadn't screamed out so loudly no one would ever have known he had tried to open the door in the first place. His mother insisted that he should not be allowed to wander about and play in the bakery on his own after that. He had to have that dreadful Hildy with him always. He really hated her.

But hate her or not, his Father's new rule stood:
'NO PLAYING ALONE IN THE BAKERY!'
He smiled to himself. If only they knew. Whenever he couldn't get to sleep at night, or woke up for any reason, he had got into the habit of creeping downstairs to the bakery and pretending that he was making a batch of bread or cakes or anything that took his fancy. He would imagine he was lifting the big flour bin, (it was too heavy for him to move really), and then he would add the various ingredients and roll the imaginary dough, shaping the handfuls into the right size for a loaf as he had seen his father doing. And then of course, he would imagine using the big wooden shovels to push the dough to the furthest reaches of the deep ovens. It was marvellous fun!

But here, now, in the candlelight, he had a chance to actually light up the fire and make his dreams come true. He had seen it done so many times and wouldn't make the same mistake this time. This time he would put on the thick glove before he touched the metal door. He wasn't going to get into trouble for burning his fingers again.

When he went to look he found that the fire box was all stacked with wood ready for lighting…Marvellous!

In no time at all he had used his candle to

Detail

Old St. Paul's Cathedral was completely destroyed in the fire. The heat was so intense that the stones of the building 'exploded like grenados', and molten lead from the roof 'ran down the road like a stream'.

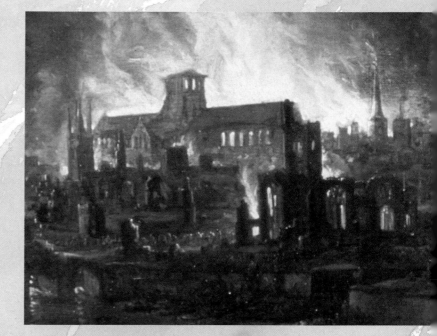

set fire to the kindling and when the wood itself started to burn, he dragged on the big glove and closed the metal door.

At least…he TRIED to close the door. He could not budge it! Unaware that the door fitted into little slots, and that it had to be lifted a fraction before it would turn, he struggled unsuccessfully to close it. The fire started to lick out around the door and eventually he had to stand back and watch in mounting fright as the flames began shooting across the room.

He would certainly get into trouble now. In a panic he climbed up and put the tinder-box back in its place. In getting down he caught his heel in his night-shirt and fell, knocking the stool over and frightening himself even more.

He was half way up the first flight of stairs before he remembered he had left his candle on the floor, but by then he was too afraid of the trouble he was going to get into to turn back. As quickly and as quietly as he could he made his way back to his bedroom, climbed into bed and pulled the sheet up over his head. When they came to wake him to tell him that someone had lit the fire down in the bakery, he would pretend to be in a deep sleep.

Back on the ground floor, the stool, which had rolled to a stop a few inches from the open fire door, slowly blackened where it lay and

finally burst into flames. The door that Frederick had left slightly ajar in his panic, created a fierce draught that eventually turned the whole room into a raging inferno.

Up in his bed the little baker soon became aware of the choking clouds of smoke. He had to do something! He should tell his father what he had done. He would get into awful trouble, but he was more frightened of the flickering glare coming from downstairs than he was of any punishment.

He made his way through the smoke to his parents' room and nervously woke them both. In what seemed like an instant he was being hailed as a hero. His mother kept hugging him, murmuring, 'You clever boy! Thank heaven you woke up or we'd all be dead in our beds!'

Father had immediately taken charge, leading family and servants up onto the roof and across to the next house and safety.

Through all the telling and retelling of the story, Frederick steadfastly denied that he was a hero, but even in later years when he was a grown man, he still could not pluck up the courage to reveal what really happened on the night that he started the Great Fire of London.

Who knows? Perhaps that's the way it really started. What is definitely known is that the Great Fire of London began in the King's bakery in Pudding Lane just north of the Old Billingsgate Fish Market, and in the four or five days that it burned, 13,200 houses were destroyed, 87 parish churches and 44 of the Grand Livery Halls went up in smoke, and thousands of people were left homeless.

The Dutch painter of this work was probably an eye-witness to the conflagration, because this picture is less exaggerated than most other paintings of the Great Fire and as you can imagine, there were many works done on this subject.

The building slightly left of centre is the old St. Paul's Cathedral. The heat was so intense that eye witnesses described the stones of the building 'exploding like grenados' (grenades), and the lead from the roof melting and 'running down the road like a stream'.

Old London Bridge, with houses and shops built on it, is on the left and on the right, looking as if it is picked out by cleverly positioned spot lights, is the Tower of London.

It is interesting to note that the artist has put in an imaginary wharf below the Tower, and crowded it with refugees and looters to give the feel of what really went on. It is actually amazing, considering that over three-quarters of London was destroyed, that there was so little loss of life. Hardly anyone tried to fight the fire, apparently. Most people were intent on saving their lives and whatever belongings they could carry.

Joseph Wright of Derby
(1734-97). *The Alchemist.*
1771. Oil on canvas, 50 x
40 in. (127 x 101.6 cm.).
Derby Art Gallery.

THE ALCHEMIST

As a lad I thought I had invented a new method of painting portraits. I would get a single source of light, like a candle or a single electric light and sitting the model down I would arrange the light so that an interesting arrangement of harsh shadows fell across the features. Then I would draw, as accurately as I could, a sort of map of the light and dark areas, and if my drawing was good enough, when I coloured in the shadow areas with black, the face would seem to jump out in three dimensions from the page and it was a very recognisable portrait. I called them 'shadowgraphs' and expected to take over the world with this revolutionary new art form.

Little did I know that artists had been doing this sort of thing for centuries. People like Caravaggio, and the man who painted this picture, Joseph Wright of Derby, were obsessed with painting dramatic lighting effects.

RIS, from the last three letters of my surname, was how I signed my name when I was fifteen. I thought 'shadowgraphs' would sweep the world! They were made quite simply by accurately drawing a 'map' of the edges of the shadows and filling in the appropriate areas with black paint.

Joseph Wright has very skilfully arranged his three different sources of light. He was very interested in science and to get authenticity into the painting he painstakingly followed a description of how phosphorus was made which a friend of his had just translated from a French chemistry manual. Nothing in the whole picture is as bright as the glass sphere containing the gleaming phosphorus, and look at the strong way the shadows have been drawn and painted on the old man's robes, the papers, and the globe up on the shelf. The black piece of apparatus in shadow down in the right-hand corner gives a lovely contrast to the brilliance of the phosphorescent glow.

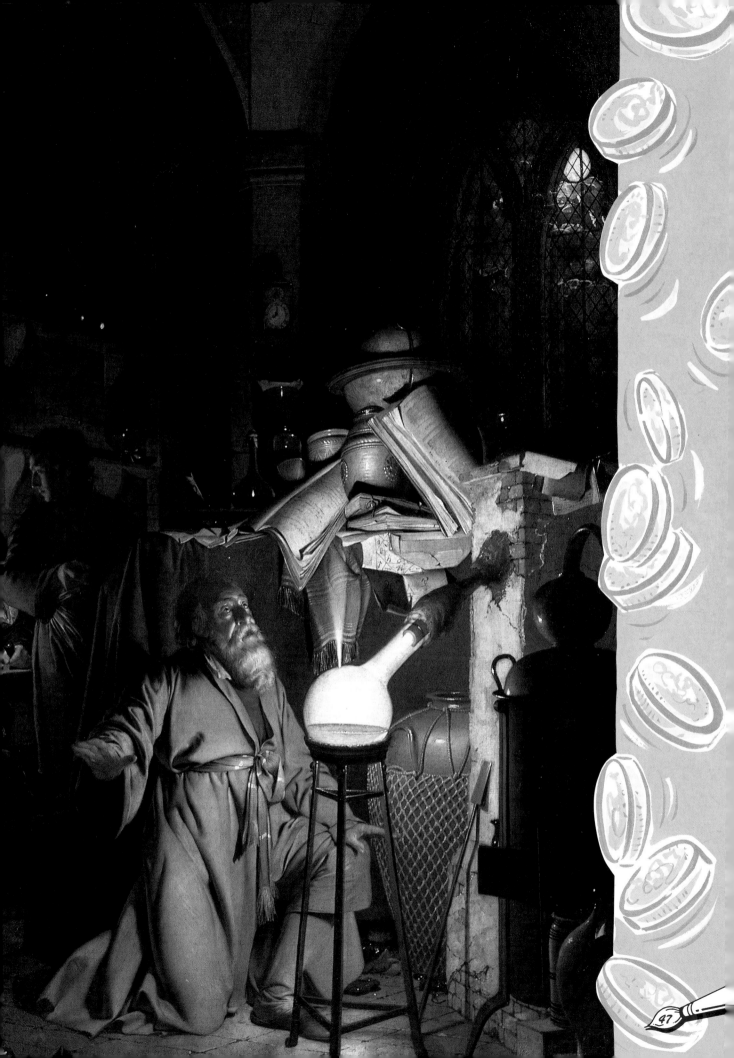

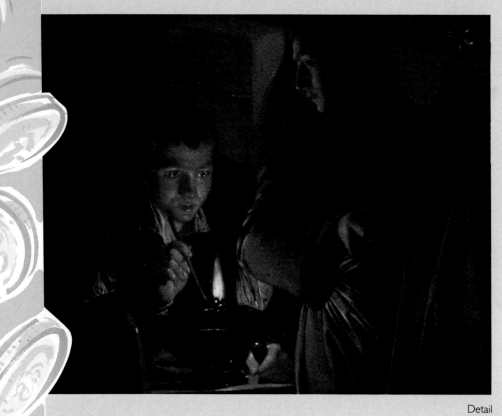

Detail

Detail

Now cover the bottom right-hand corner of the picture so that the effect of that brilliant white light is blotted out. Suddenly you notice the cosy warm reds and oranges from the weak little glow of the single candle. In its own way this tiny light paints shadows which are every bit as strong as those on the old man's garments. It is nice to see that the reddish glow of the candle only extends halfway up to the huge vaulted arches. After that, the candle's light has died and you get the cold reflected greenish glow from the objects lit up by the phosphorus. Wright has skilfully isolated the candlelit section from the phosphorescence by putting that green blanket covered chunk of furniture to block the light, otherwise of course, the subtlety of the candlelit scene would have been blocked out by the fiercer white light.

Then of course, away up in the corner you get another cold light from the moon. Tonally, the moon is only about as bright as the sheen on the huge string-covered earthenware pot by the old man's left hand. It is beautifully painted, tonally controlled throughout.

Do you know anything about alchemists? In some ways they were very like the medieval experimenters before them as they believed that things had magical properties. They mixed all sorts of folklore and myths and mumbo-jumbo with so called scientific experiments. The Alchemists' big dream was to discover the fabled 'philosopher's stone' as it was called, or the elixir of life, and once they had those they thought that they could turn base metals like lead, tin or iron, into gold, which would make them rich and famous for all eternity.

Of course, come the eighteenth century all this hocus-pocus gave way to more scientific approaches. Chemists, physicists and biologists realized that advancement lay not in chanting curses and magical slogans while they worked, but more in controlled experiments, detailed notes, and exact measurements of everything that had a bearing on results.

Joseph Wright has captured the cluttered nature of the old man's experiments perfectly, so in a way he has made the Alchemist immortal after all.

WILL-YOU-STOP-THAT INFERNAL "SPACE INVADERS" RACKET! HOW CAN I CONCENTRATE?

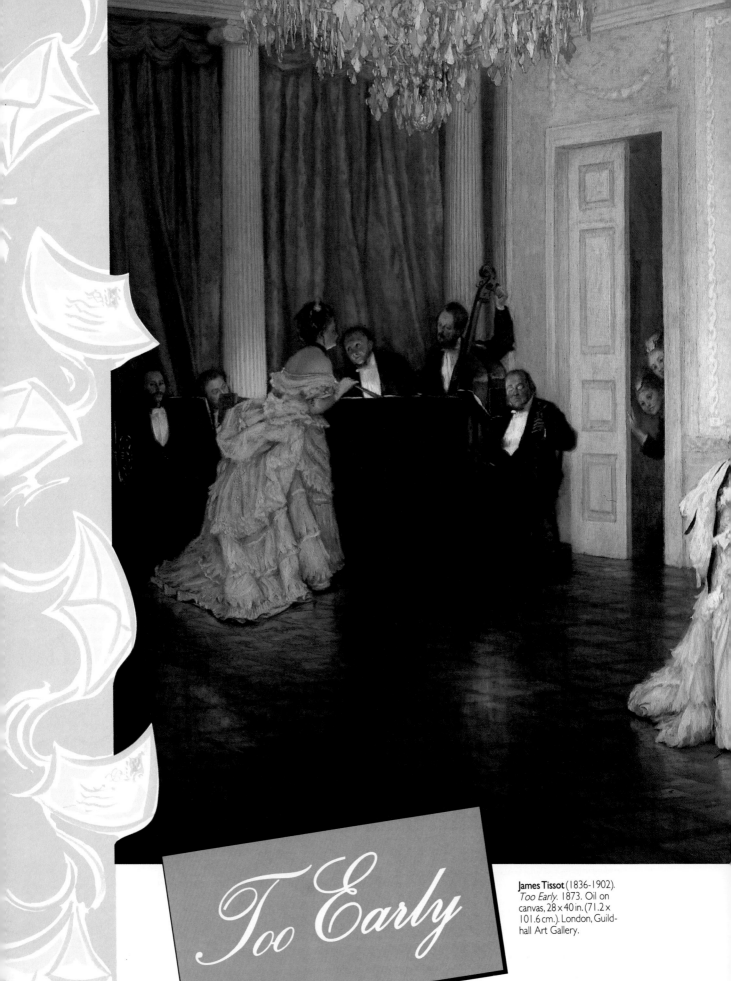

Too Early

James Tissot (1836-1902). *Too Early*. 1873. Oil on canvas, 28 x 40 in. (71.2 x 101.6 cm.). London, Guildhall Art Gallery.

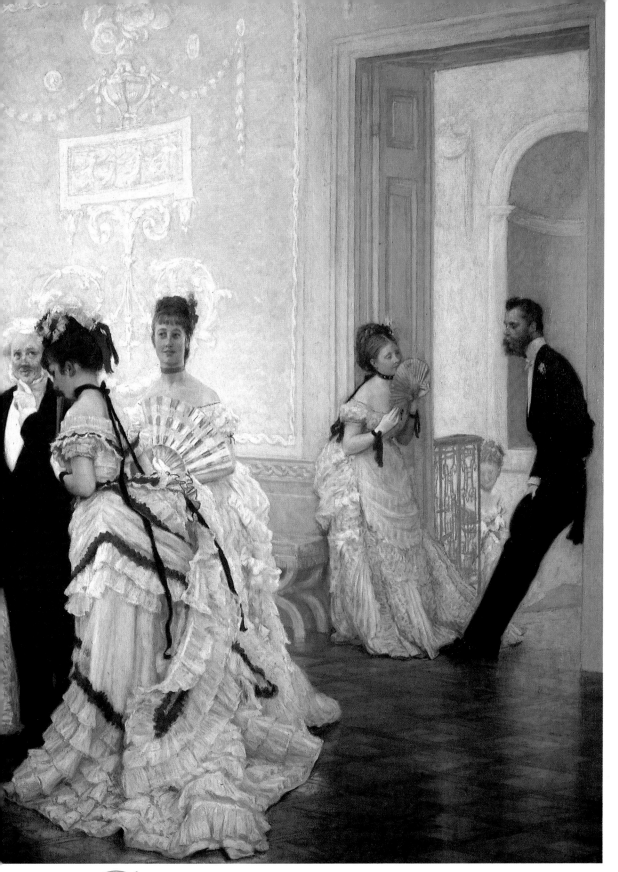

Pictures like this conjure up all sorts of possibilities in your mind as you look at them. This one is most exquisitely painted by James Tissot. You could lose yourself in admiration of the fine detail and muted subtle colours of the central wall decoration, or the chandelier. The reflection of the light on the highly-polished parquet floor of the ballroom almost makes you want to be careful as you walk in case you slip.

Look at the superb detail in the gowns of the hostess and the guests, amazingly portrayed down to the painting of actual seams and tiny buttons. Tissot's parents were both a bit involved in the fashion and textile world and it is obvious that he has picked up and nurtured this interest.

But the central core of the painting that

Detail

One young lady tries to put on a brave face, but the embarrassment is obvious from the poses and facial expressions of the other two guests.

really grabs my attention is the way that the faces and general poses and attitudes of the people in the picture conjure up a story immediately in my mind.

Who do you think they all are?

The group at the far end in dinner-suits and bow-ties are obviously musicians, being told by the hostess, in no uncertain terms, exactly what she wants from them during the course of the evening. But just look at the faces and poses of the others. I can see it all. With a little prompting from the title *Too Early*, the whole story presents itself...

The poor fellow in the middle with the three ladies is a junior partner in some city firm. If I were Charles Dickens I would immediately call him Snipe, a widower. He has received an invitation from Sir Boynton Hemsley, senior partner of the firm.

'A little supper do, old boy. Wife insisted we must lure you out of the house,' he had boomed, the voice of authority. 'You've been such a stick-at-home since your loss...A year's long enough...What?...What?...

Whole family invited...Next Friday...All there in the invitation...Must go.' That was the way he spoke, or barked rather, in short unconnected bursts.

That evening Snipe had paid off the Hansom cab, as he always did when the weather was fine, and walked the last mile or so through the park. It saved money and gave him a good healthy appetite. Eventually he left the new Regent's Park Zoological Gardens far behind, and was crossing over Regent's Park Road when he thought he would just have a peep at the actual invitation. He had planned to give it, unopened, to his eldest daughter when he got home. She had taken over the running of the household since his wife died, and she would efficiently note all the details and make all the necessary arrangements.

He lifted the flap of the envelope and pulled the richly embossed card free. The words 'Sir Boynton and Lady Hemsley invite...' had just come into focus, when a sudden shout of 'Mind yerself guv'nor!' jolted him back to reality. He realized he was crossing the little

Detail

The hostess instructs the musicians as to what she requires, while two servants peep around the door hoping to catch a glimpse of the early guests feeling uncomfortable.

52

bridge over the Regent's Park Canal and had forgotten how narrow the road became at that point. The footpath on his side of the bridge was almost non-existent. The horse's head looked enormous, and the Hansom-cab driver was dragging on the reins to pull the beast to the right. There was hardly any room! Snipe flung himself back hard against the brickwork of the low parapet and felt the precious card jolted from his fingers at that instant.

There wasn't even room for him to turn until the horse and carriage had scraped by, and when he was finally able to look over the edge there was no sign of the invitation, all he could see was the end of one of the canal boats disappearing under the bridge.

He rushed across the road to the other parapet and was just in time to see the tail end of the boat appearing. 'Have you seen an invitation?' he yelled. The woman steering the barge looked round in fright and he had to shout his question again. She called back something or other, but it might just as well have been in Dutch for all he understood of it. Her man was a long way ahead trudging alongside the big old horse that was pulling the boat, and there seemed no way, or indeed, no point in trying to stop him. The boat slowly moved on into the gathering gloom.

There was no sign of the invitation from either side of the bridge, and no way down to the water's edge anyway, unless he had lived in one of the houses backing on to the canal.

When he got home his daughters, son, and daughter-in-law all called him a silly old duffer, in a loving way he hoped, but that did not bring the invitation back. A family conference decided that a supper invitation from so important a man as Sir Boynton Hemsley would be for around half-past six in the evening. Snipe himself did not dare approach Sir Boynton and admit he had lost the invitation. He felt stupid enough as it was, and mentioning the supper invitation to any of the other business partners might make

them jealous of not having been asked themselves.

Eventually, on the Wednesday, Sir Boynton's private secretary, a very superior sort of man with a rather unpleasant face, poked his head around the door of the office.

'You haven't R.S.V.Pd!' he said.

'I beg your pardon?' (Snipe was completely flustered.)

'Didn't you see R.S.V.P. at the bottom of the invitation? They need to know if you're coming. The catering people...Well?'

'Oh yes, well of course, er, all the family... er, yes certainly...very thrilled to have been asked', he muttered.

'Why on earth you couldn't have told me that earlier in the week...' he turned on his heel.

'Er...excuse me, er...what time should...?' He was speaking to an empty space. The secretary had gone.

And now here they all were. They would be the laughing stock of the company. They had arrived promptly at half-past six, having insisted that the hired carriage wait just around the corner until the time was right. His son and daughter-in-law hadn't really wanted to come, but had eventually dressed themselves very fashionably, and his daughters looked absolutely marvellous, even if he did say so himself. At the stroke of half-past six they had presented themselves at the front door, pulled the bell and waited... and waited. Finally a very flustered looking footman arrived, stared at them all in open-mouthed amazement, invited them in to the hall, and set off, as he said, to try to find the mistress of the house. And there, once again, they waited...and waited.

When Lady Anne did arrive, it was obvious from her manner that she was quite put out.

'You are *extremely* early', she said. 'We were expecting the first arrivals for the supper dance at eight. You surely had the invitation?'

'Ah yes', stammered Snipe. 'Please forgive me, I must have misread it. Look, we'll go away and come back at a more sensible time.'

Lady Anne would not hear of it. 'Nonsense! Where would you go? You won't mind if the final preparations go on around you will you? Come on up to the ballroom all of you. No chairs there yet, but Jamieson will be sorting that out shortly, and I have to discuss with the musician people exactly what I want them to do. You can't trust anyone to do anything nowadays...' (It sounded like a very personal comment.) 'Make yourself at home'.

And so...here they stood, appallingly early. If his hair was not already white, Snipe was sure it would be turning that colour as everyone watched. He turned on hearing a stifled giggle from behind him, and there stood two servant girls enjoying the family's discomfort. This was the last straw. If only the floor would open up and swallow him whole, right now, in one big gulp, he would be perfectly happy.

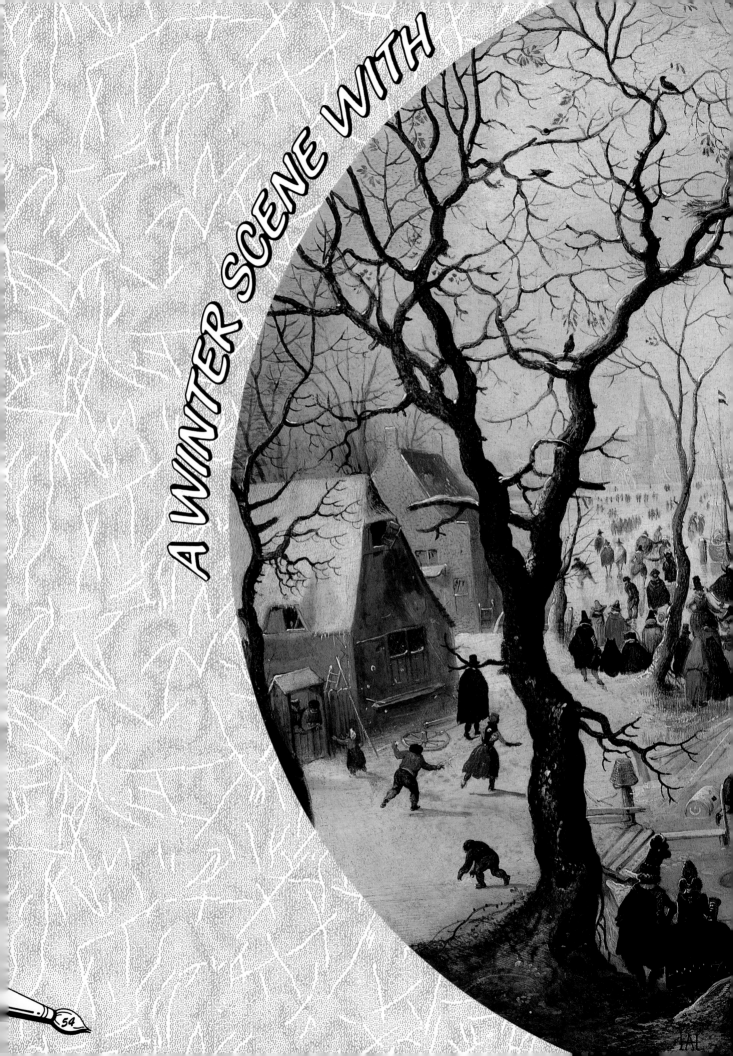

A WINTER SCENE WITH

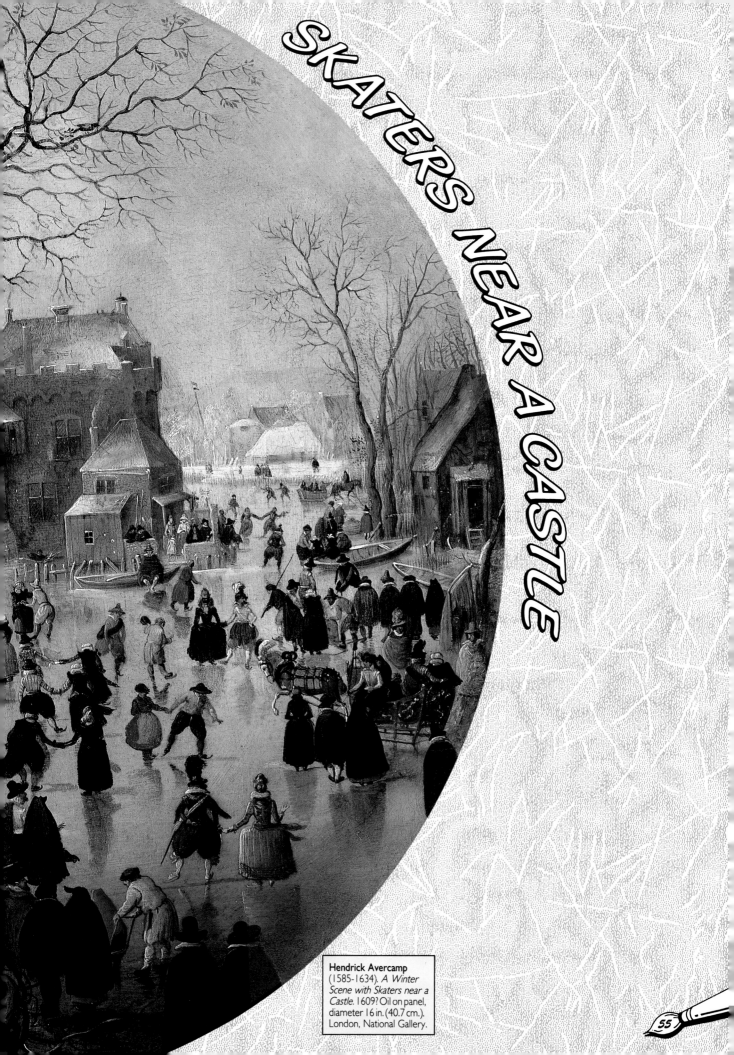

SKATERS NEAR A CASTLE

Hendrick Avercamp
(1585-1634). *A Winter
Scene with Skaters near a
Castle.* 1609? Oil on panel,
diameter 16 in. (40.7 cm.).
London, National Gallery.

Growing up in Perth, Western Australia, I never had any contact with ice, except the manufactured variety that was sold in summer to fill the old fashioned ice-boxes, the forerunner of the modern refrigerator. Actually, it was only rarely that I saw the ice being brought around in big blocks by horse and cart, because we, as a family, didn't own an ice box. I think it was too modern for my Dad, or perhaps too expensive.

The first and only time I went on the ice over in the U.K. was at Streatham Ice Rink, and it was a disaster. I probably had the wrong-sized boots, but whatever the excuse, all I know is my ankles seemed to flip from side to side. One minute my skates were flat on the ice and both inside ankles were too, and the next instant it was the reverse, the soles of my feet facing one another as it were, and my outside ankle bumps touching the ice...Disaster, as I said. You can imagine therefore how I envy all these people in this picture as they calmly slide around on their beautifully upright skates.

It is a measure of how our climatic conditions have changed over the centuries that we haven't seen a winter as cold as this in our lifetime really. When this was painted, around 1600, the rivers and canals would freeze like this every year in the low countries. In England the Thames would be frozen from bank to bank and fairs would be held, and fires would be lit on the ice. As you can see in this painting, the ice was thick enough to support a horse-drawn sleigh. People would take out stools and chairs, drill holes in the ice, and sit for hours fishing.

This painting is a marvellous record of the times and the way people dressed. Rich and poor, they are all out on the ice. The ones in the ornate fashionable dress, men in huge balloon breeches and women in sort of crinoline-type gowns, look quite incongruous when you think of modern skating outfits in competitions. You can see one man, near the

After drawing the tree and the top-hatted figure, I thought I would try an impressionist-type painting of the whole thing. As you can see, once you have removed colour differences, you can concentrate on the tone, that is the lightness or darkness of each section. I have concentrated on the front figures, imagining that my eye is focused on the fore-ground, and that the rest of the picture gets more blurry as it gets further away from me.

'89

submerged barrel in the foreground, helping a lady on with her skates, and in the background almost at the centre point of this circular picture you can spot a couple taking a tumble. I can identify with that!

It suddenly struck me as odd how many people were standing or moving with their back to me. I counted them and there are over seventy back views and fewer than thirty side or front views of people in the picture. Perhaps the artist was better at backs than fronts!

A couple of other things strike me as I look at the picture, and one is that the painter deals with distance in strangely different ways. There seems to be no consistency about how he tackles the fading colours in the distance. The huge foreground tree is very dark brown, almost black, and as you move halfway towards the castle-shaped building in the middle you see the next tree is handled with much paler colours. Unfortunately the black paint on the figures is not made pale in the same way, so you get no sense of the reality of the distance between you and the people.

A very glaring example of what I mean is the branch on the left of the foreground tree which appears to be almost a part of the hat on the cloaked figure, who has to be a good thirty feet away from the tree. As it is he looks a bit like someone wearing a reindeer's antlers attached to his hat.

I also find the addition of the gleaming white snow all over the picture very disturbing for this same reason. The snow on the castle-like building and on the boats is as white as the snow on the foreground tree. I would have liked the picture so much more if the snow highlighting things in the distance was slightly greyed – something like the colour of the snow on the roof of the barn on the extreme left. The scene would have worked better too, I felt, if it had been a little less pin-point sharp in detail as it got further away, but the age of the Impressionists, who did this particularly well, was some three hundred years into the future when this painting was being done.

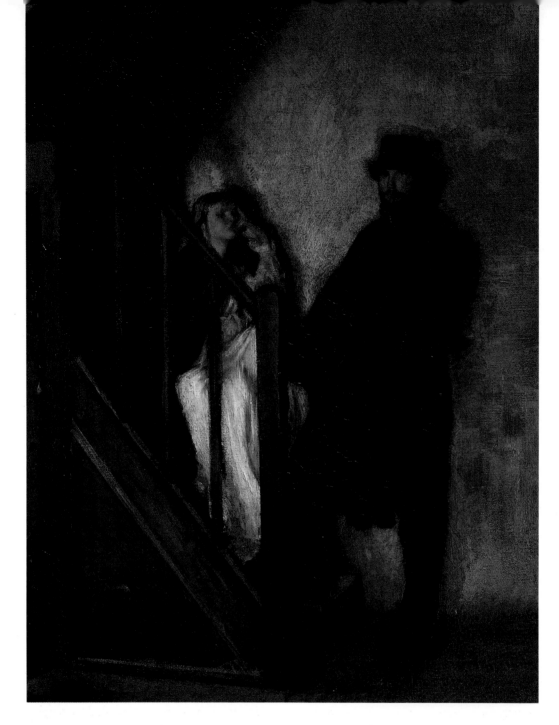

Rothenstein's claustrophobic picture shows a rather pompous, self-centred man, very sure of his own importance and position in society. The woman has seen through him at last and realizes what a broken reed he is. Do you know the story? Rothenstein's painting was inspired by Ibsen's play *A Doll's House*. As the artist said, 'We were all mesmerized by Ibsen in those days.'

The play was written some twenty years before this painting was undertaken, and the story is typical of the fairly grim and austere stories that Ibsen wrote. Torvald Helmer, he of the top hat in the painting, is a lawyer who has struggled in relative poverty for years and has finally landed a marvellous job as the manager of a bank. A letter from one of his employees, Nils Krogstad, has revealed that some years earlier Helmer's wife, Nora, had forged her dying father's signature on a document to arrange a loan. It was Krogstad who arranged the loan at that time, and his new employer, Helmer, was about to sack him after he discovered some previous shady dealings that Krogstad had been involved in. Krogstad is now using his knowledge of Helmer's wife's forgery as blackmail, to not only avoid the sack, but to demand a better job into the bargain. He has the forged document in his possession.

An added complication is that Helmer and Krogstad had been friends in their youth. What an embarrassement for the pompous Torvald Helmer! To him, the worst feature of the whole affair is not the debt, the deceit, or the forgery, it is the fact that his wife Nora would have put him in a position where his good name could be threatened by blackmail.

Helmer is so incensed and outraged that he doesn't give his wife a chance to explain, and it would have been quite a pertinent explanation, had he only listened.

The facts were that Nora had been told many years earlier that her husband's life was in danger due to ill-health, and that his only chance of surviving at all was to take a long holiday in a warmer climate. To pay for this she had secretly arranged for her old father to take out a loan through Nils Krogstad, who was aware that the old man was too sick to sign any documents. She had forged her father's signature and as a result of the year's holiday in a better climate, her husband had fully recovered.

Now this same husband, this Torvald Helmer, is shouting at her, 'Don't come to me with a lot of paltry excuses...Oh what a terrible awakening this is. All these eight years ...this woman who was my pride and joy...a hypocrite, a liar, worse than that, a criminal!' (and all this to the devoted woman who has risked everything to save his life)! He goes on...'Oh, how utterly squalid it all is! Ugh! Ugh! You have ruined my entire happiness, jeopardized my whole future.' He paces the room, almost ignoring her pleading looks, seeming to talk only to the wall. 'The thing must be hushed up at all costs.' He glances at her from under frowning, disapproving brows...'As far as you and I are concerned, things must appear to go on exactly as before. But only in the eyes of the world of course.' He spins around on his heel and glares straight at her. 'In other words, you'll go on living here; that's understood.'

Every word must have sounded like a nail being driven into a coffin, a coffin bearing their loving relationship of the previous years of marriage. Nora starts to see for the first time the real character of the man she thought she loved. 'But you will not be allowed to bring up the children' he carries on, oblivious of all else, wounded pride spurring him on. 'I can't trust you with them...oh that I should have to say this to the woman I loved so dearly, the woman I still...' he turns to look at her briefly...'Well, that must be all over and done with from now on, there can be no question of happiness.'

His wife, as you can imagine, is stunned, she can only mutter lifeless, one word answers. She had expected him to have quite a different reaction, thought he would be grateful when he found out the source of the money for that life saving holiday.

In a later scene in the play she says to Helmer, 'It never so much as crossed my mind that you would submit to that man's conditions. I was absolutely convinced you would come forward and take everything on yourself, and say "I am the guilty one".' Helmer replies, 'I would gladly toil day and night for you, Nora, enduring all manner of sorrow and distress. But nobody sacrifices his *honour* for the one he loves'. The final nail is driven into the coffin lid!

When he forgives her later in the play it is too late. Nora decides to leave him in order to find out what sort of person she is for herself. As she says in the speech that gives the title to the play, '...our house has never been anything but a playroom. I have been your doll wife, just as at home I was daddy's doll child. And the children in turn have been my dolls. I thought it was fun when you came and played with me, just as they thought it was fun when I went and played with them. That's been our marriage, Torvald. If I'm ever to reach any understanding of myself and the things around me, I must learn to stand alone. That's why I can't stay here with you any longer.'

The Doll's House is a powerful stage play, especially in the social climate of the time when it was written, the late nineteenth century. It was questioning all the stodgy social values and examining the woman's role in a new light. It must have been quite a shock to male Victorian playgoers.

Does the painting suggest any of the above things to you? Nora sits on the stairs in a slightly petulant way, one finger in her mouth, suddenly seeing her man for what he is. He stands there striking a noble, statuesque pose as though for a photograph to impress his business associates. What he is saying is undeniably right and would be approved of by society. (You can almost hear him thinking 'I hope my hat is on at the right, slightly rakish angle'.)

An interesting aside is that William Rothenstein's models for the painting were his new wife, Alice Knewstub as she was, and his fellow student at the Slade School of Art, a man who was to go on to great things, Augustus John.

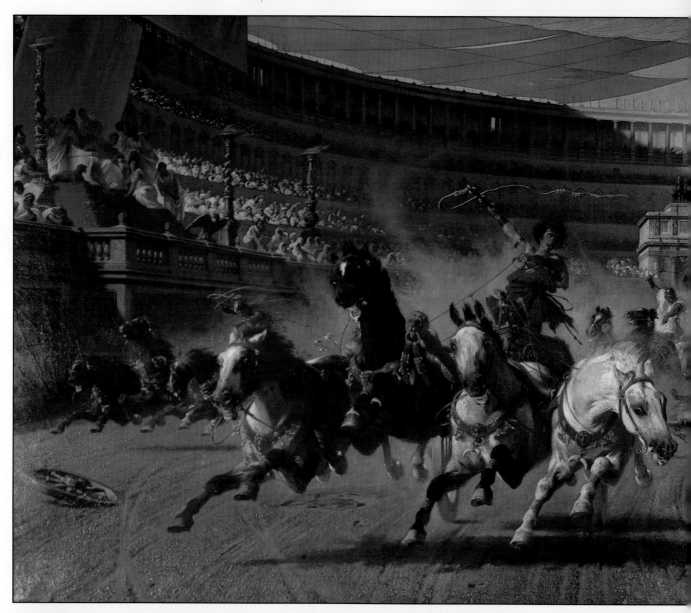

Alexander von Wagner (1838-1919). *The Chariot Race*. 1890s. Oil on canvas, 54½ x 136½ in. (138.4 x 346.7 cm.). City of Manchester Art Galleries.

What a stunning effect this painting has on the eye. If you didn't know better you would almost swear that it was a still frame taken from a wide screen movie epic of the 1960s.

The enormously wide-angle effect pre-dates 'Cinerama' by sixty or seventy years. This painting puts you in the middle of the action and stuns and overwhelms you with the sheer size and spectacle of everything going on.

The feeling of action and movement achieved in this painting is quite extraordinary. It has the same breathtaking quality as watching one of those three-dimensional cinema experiences which puts you in the front seat of a roller coaster. You would swear that the painter was sitting, strapped in, facing backwards in the seat of

the lead chariot, which is going at the same breakneck speed as all the others (and thinking incidentally, 'I hope that's not the wheel from our chariot!').

Historically, I don't know whether photography was far enough advanced for the artist to have been able to get reference shots of horses galloping towards him in this way, probably not. In any event it's a remarkable effect he has achieved.

Scenes from Greek and Roman history were very popular as subject matter for artists in the eighteenth and nineteenth centuries. Painters did enormous amounts of research into what clothing and jewellery would have been worn, weaponry and artefacts, household utensils and so on, in an endeavour to make their pictures as authentic as possible. Some of

This stunning 'wide screen' effect of horses galloping straight at you was painted long before the wide-angle lens was ever invented.

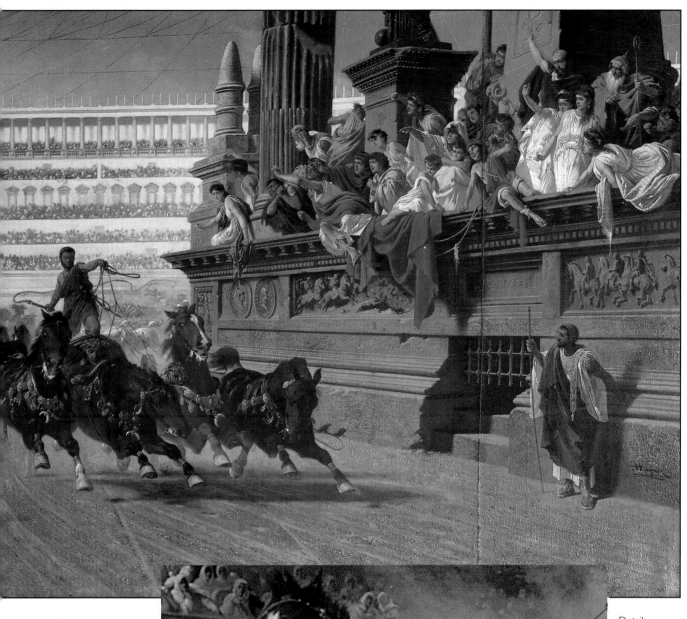

Detail

these works were of everyday domestic scenes, some showed historical events, and some, like this one, went for pure spectacle!

Alexander von Wagner was born in Hungary, and as a young man he studied at a school in Munich which specialized in reconstructing scenes from history, on a grand operatic scale.

Well, you couldn't have asked for anything much grander than this scene showing chariot racing in the *Circus Maximus* in Rome. Put yourself there. You have been lucky enough to draw third position in a field of eleven teams. This means that you are fairly close to the central island of the huge oval stadium, and given any sort of decent start you might be able to cut across ahead of teams one and two and hug the island as you career round the track. Every charioteer has driven his team of horses to its allotted position, turned to face the Emperor and then backed the four horses into place. The tension is not as fierce as it will be before the actual start, but hearts are certainly racing already.

In the comparative darkness of the assembly area underneath the central island, owners and well-wishers pass on good omens and advice, and you have just been warned to watch out for Sergius Brutus at number seven position. He has the reputation of stopping at nothing to win, and your owner has fearfully pointed out that he has the multiple-headed serrated swords fitted to both wheel bosses. Anything is legal in these races – in fact the more gore and destruction the better the public like the spectacle, and after all, the whole thing is only staged to keep them happy.

It is rumoured that well over 250,000 people are in the gigantic stadium, and the sight of one chariot remorselessly grinding the spokes out of another chariot's wheel while doing breakneck speeds down the straight, is the sort of thing they come for. If someone is hurt in the subsequent upending of the chariot, then so much the better.

The trumpet call for the 'walk around' lap stops all further worrying, and you move your team out into the blinding light and meet the deafening sound of the crowd. For a brief moment all the teams face the Emperor seated at the base of the huge Imperial Eagle. They then perform a slow wheel to the left. In a remarkably short time the circuit of the course has been completed and all the competitors are back in a straight line across from the Emperor. Fancy colours and cloaks have been discarded and every eye is on one or other of the flags. The great man stands, raises his right hand with the white cloth in it, and after an agonizing wait it's a clean start. Cloth and flags are down and the thunder of hooves is drowned by thousands of voices.

And now it is only a matter of trusting that marvellous team of horses and staying out of trouble.

Three times in the race Sergius Brutus has trapped a chariot, either so close in to the island that he cannot escape, or, as in the case of the third incident, so close to another chariot on his left-hand side that both of the charioteers came to grief. He worked with cold calculating skill, matching his team's pace to that of his opponent's team, and then steering in to them slightly, so that the whirling blades on his wheel boss grind relentlessly into the rotating wheel of his victim's chariot. In a short time the wheel, stripped of its spokes, flies off – and it is all over for one more charioteer.

There are only two more laps of the *Circus* to go, so, if you are to win, you must make your move.

A surge of speed brings you level and Sergius sees you and steers slightly your way. The spinning blades are hypnotic but somehow you tear your eyes away and urge your team on so that your wheel is just ahead. The blades shred the fancy woodwork just to the rear of the wheel and you are about to congratulate yourself when you feel the sting of his whip across your shoulders.

You dare not take your eyes from the gap between his wheels and yours, so you are forced to take the lashing blows. Great welts appear on arms and shoulders, but strangely enough, the excitement is so great that you feel no pain. On the fifth brutal attack with the whip you hold out your right arm, free at that very instant from the reins. The end of the whip snakes around your arm and you have him. You have him! A quick winding of the wrist and you are almost up to the handle so that when you jerk across your body with all the frenzied strength you can muster, he is totally unready and lunges unwillingly over the side of his chariot to be dragged along the ground by his own reins. You are over the finish line a mere horse's length ahead. You have just won the coveted laurel wreath at the *Circus Maximus* in Rome!

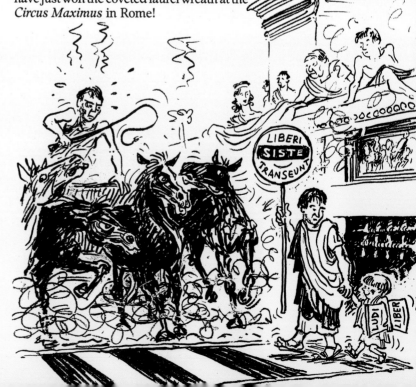

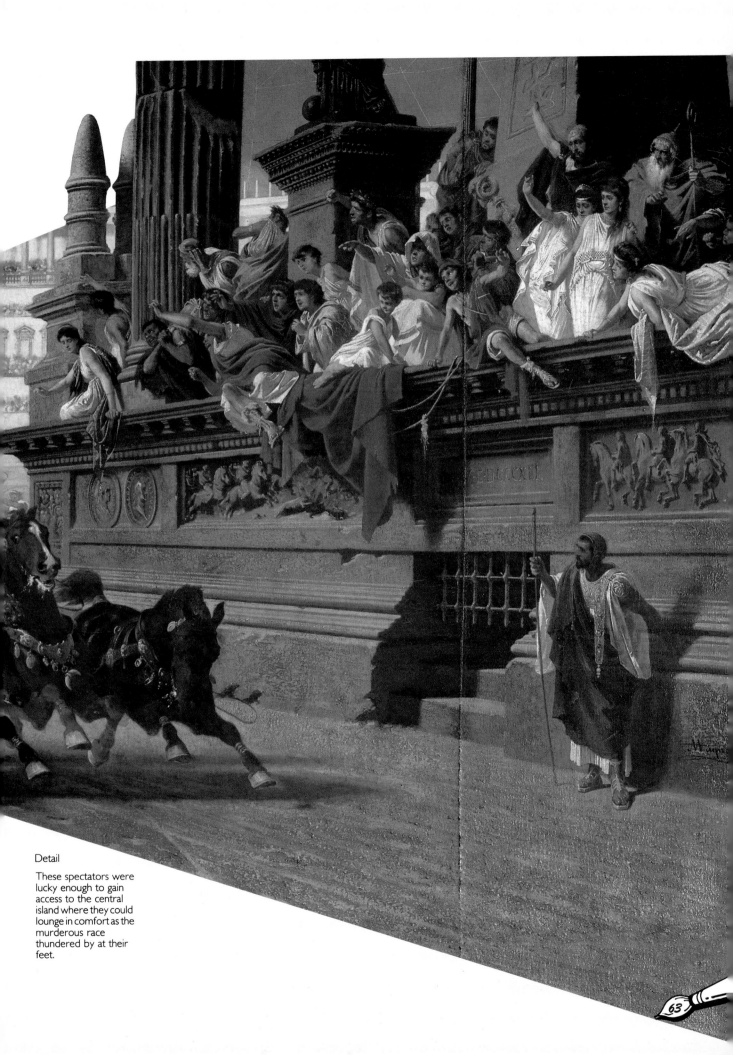

Detail

These spectators were lucky enough to gain access to the central island where they could lounge in comfort as the murderous race thundered by at their feet.

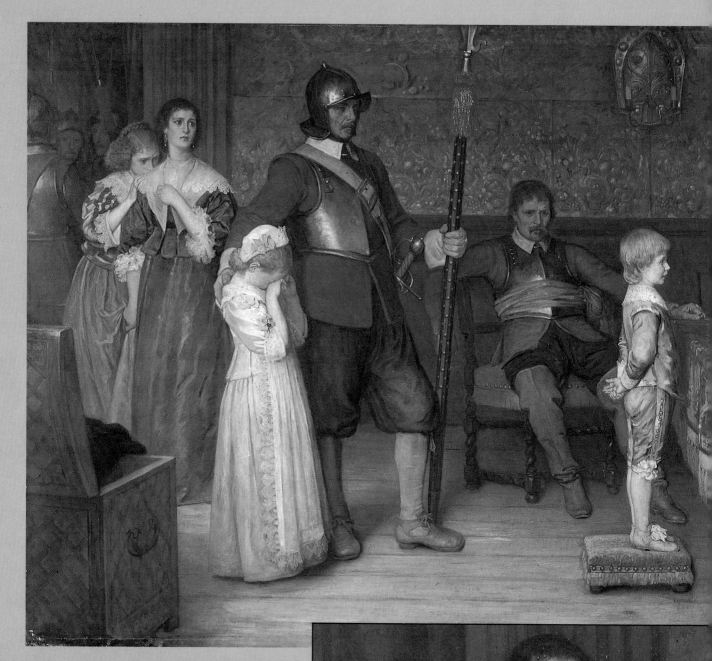

eames' painting captures marvellously an underlying current of sly menace in what, on the surface, looks to be a very civilized meeting of people. Glance at the three women on the left and immediately you realize that they are terribly concerned about the seeming innocence of the question from the man in command, the question in the title of the picture. To fully appreciate the charged tension in that room you should know the background of events which led up to this confrontation.

This painting is set in the Civil War fought between the Puritans, or Roundheads, as they were called, (due to the shape of their metal helmets) and the Royalists, or Cavaliers. The war started really as a civil disturbance over King Charles I and his authority, or in fact,

Detail showing the worried womenfolk.

AND WHEN DID YOU LAST SEE YOUR FATHER?

William Frederick Yeames (1835-1918). *And When Did You Last See Your Father?* 1878. Oil on canvas, 48 x 98 in. (122 x 249 cm.). National Museums and Galleries on Merseyside, Walker Art Galleries.

his ability to govern the country. Parliament at that time was just a supporting body and not the centre of real power as it is today.

People were worried about the King's apparent leaning towards the Catholic church and eventually everyone was forced to take sides in the growing row. Some people backed the King, even if it was because they respected the idea of the Crown and the Monarch rather than the man himself. Those who opposed the King on religious grounds moved to the side of the Parliament, and soon armies were recruited and many bloody battles were fought. The Parliament's forces, the Puritans, shunned the lace, frills and fine apparel of the Royalists, and dressed in very dull unornamented clothes, so this difference widened the gulf between the two factions.

You can see this difference clearly in the painting with the silks, lace and decorated shoes on the one hand, and the drab purposely dull olives, browns and greys of the hard-wearing material on the other.

It's a good painting isn't it? Every eye and every line in the painting seems to lead to the little boy. The casually dumped hat on the chair tilts towards him and the perspective lines of the table and tablecloth continue to draw your eye towards the lad's face. The horizontal line from the eye of the man on the extreme right leads you past the piercing eyes of the next two men to the eyes of the slumped man whose very position focusses all your attention back to the boy again. You can almost hear his innocent piping voice as he says ... what? What *will* he say? Will he reveal that Daddy is playing hide and seek in the priest's hole and offer to show them the mechanism that opens the hidden door, or has he picked up enough of the feelings of fear from his mother and sisters to try to tell some little white lies? If he does so, will he be any sort of a match for the apparent charm of his inquisitor?

Perhaps he knows nothing of value and will not let slip any snippets of information which could lead to the capture and execution of his father. The picture leaves you holding your breath as it were, waiting for his answer.

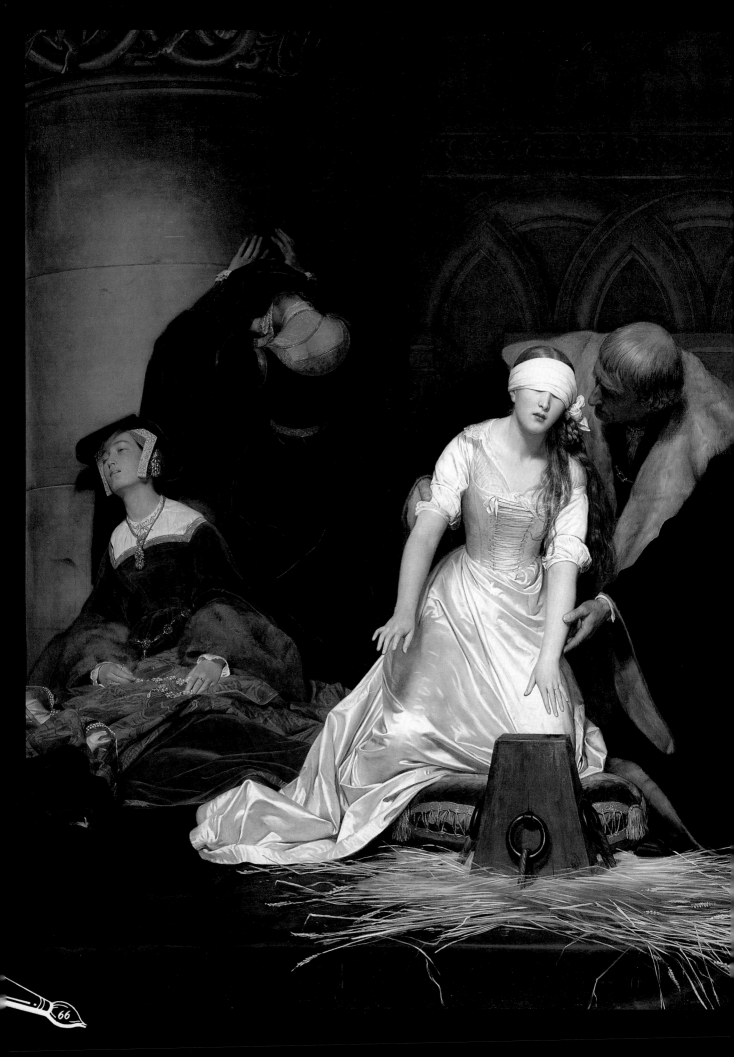

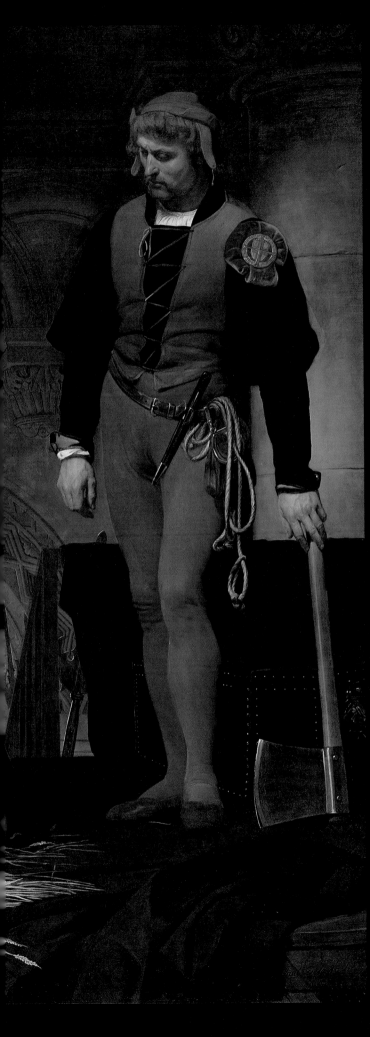

Lady Jane Grey

Paul Delaroche (1795-1856). *The Execution of Lady Jane Grey*. 1833. Oil on canvas, 97 × 117 in. (246 × 297 cm.). London, National Gallery.

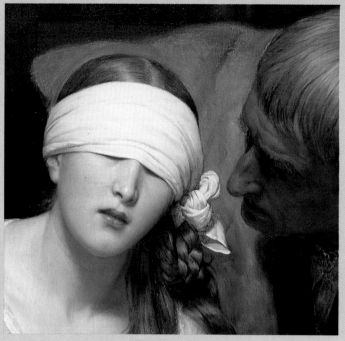

Detail

'Just sign here Your Majesty and it will be taken care of.'

The King tried to drag himself up onto his left elbow, failed, and fell back gasping in an agonising way.

'I can't,' the faintly spoken words were punctuated by painful wheezings.

'But you must Your Majesty, else one or both of your *dear* sisters will ascend to the throne in their turn.'

The Duke of Northumberland had emphasized the word *dear*, knowing how the hatred of both his sisters had fired the young King in the past.

'It's not...that I...won't...sign,' his words came painfully, 'it is that...I...cannot sit up...unaided.'

'Were I to hold you, Your Majesty, it could be said that I had forced you to sign against your will.' Northumberland cast a flickering glance around the room, taking in the various people there, mentally ticking off in his mind the pairs of eyes and of ears that were taking all this in. How many of the tongues present could he count on to wag in his favour?

'Help me to...to sit,' the King murmured, eyes closed. 'Prop me...upright...a quill... and it is...done.'

A mere flick of Northumberland's eyebrows and a tilt of the head, and one of the gentlemen-in-waiting moved forward. Together he and the Duke manhandled the King into a sitting position. The documents on a stiff writing tablet of embossed leather were laid in the King's lap, ink and quill to

hand. Everybody stepped back a pace. Northumberland watched the boy under half-closed lids. He could never think of him as anything other than a boy, and the almost feather-like weight of the King as he had helped him to sit upright a moment ago, had reinforced this feeling.

'A bundle of skin and bones,' he said silently to himself, and then stiffened as the said bundle moved, took the quill from the beautifully engraved ink-well, and shakily signed 'Edward' across the open space at the bottom of the document.

The gentleman-in-waiting paused in his forward movement until the King had replaced the quill, and then he carefully poured a measure of fine sand over the ink of the signature, lifted the document up and tapped the sand back into the small box.

Northumberland allowed the corners of his mouth to move slightly towards a smile, little knowing that he might just as well have been witnessing the signing of his own death warrant. Less than six months later he was in prison awaiting execution, as was his son, his daughter-in-law, and all who had backed her claim to the throne.

It had all started with the death of King Henry VIII in 1547. His only son, Edward, still a child, ascended the throne. The man who was supposed to be his protector until he reached maturity, the Duke of Somerset, was soon ousted by the Earl of Warwick who then had himself created Duke of Northumberland.

The King's health steadily deteriorated,

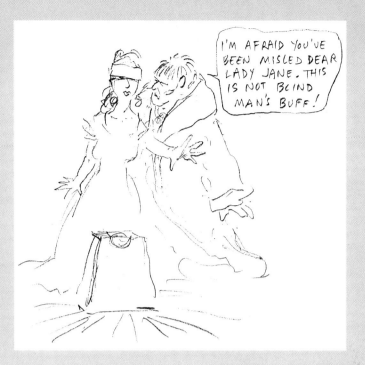

and by 1553 it was obvious to all that he was dying. The young King had always hated his two sisters, Mary, the daughter of Henry and Catherine of Aragon, and Elizabeth, daughter of Henry and Anne Boleyn, so Northumberland hatched a plot which would have kept him in power, had it worked. He arranged for his son to marry Lady Jane Grey, who in Henry VIII's will was the next in line to the throne after Mary and Elizabeth; then he set about persuading the ailing Edward VI to disinherit his two sisters.

The young King took very little persuading, and in the late spring of 1553 he signed the document bequeathing the throne to Lady Jane Grey, the eldest daughter of the Marquis of Dorset, and to her heirs.

By July of that year Edward was dead and four days later Jane was proclaimed Queen. She and her husband, Northumberland's son, ruled for a mere nine days before Mary marched on London with her supporters and enforced her own claim to the throne. Soon afterwards, Lady Jane Grey was executed.

Lady Jane Grey was one of the most important historical heroines in nineteenth-century England. She was seen as a humble, pious, gentle and tragic figure, manipulated by her father-in-law into a high position which she did not seek. In the short period in which she reigned she tried to do things which she regarded as 'right' according to her Protestant upbringing. Everything about her story appealed to the Victorians, but most of all, the strength of character shown by one so young.

The painting is fictionalized in so far as the young Queen was executed outdoors on Tower Green. Delaroche, the artist, saw a much better chance of creating a striking composition if he staged the whole thing indoors. In the setting of the Norman Hall with the huge decorated columns and the carved wall, Delaroche was able to create an atmosphere of gloom and foreboding, and was able to highlight the heroine, and catch the facial expressions of the lady-in-waiting and the attendant henchman.

Our attention is focussed on Jane because of her central position and her white attire, but our eyes are more drawn to the brightest white in the whole picture, namely the blindfold. What a feeling of panic and helplessness that blindfold gives. The painter has emphasized her youth and her helplessness by the figure of the old man who guides her to the block and seems to be whispering reassurances.

He is fictional, as history relates that Jane, attended only by two gentlewomen, made her own way fearlessly to her appointment with death.

Delaroche has certainly done his homework as regards getting the Tudor clothing and jewellery right, but in Jane's case the dress is sufficiently vague and generalized for Victorian women to identify with her, and of course, the pale skin, russet hair and slightly plump arms were every Victorian woman's notion of beauty.

About the painters

Hendrick Avercamp (1585-1634)
Dutch painter of scenes of contemporary life, especially of people on ice-covered rivers and lakes, and other winter scenes.

Hippolyte (Paul) Delaroche (1795-1856)
French painter of historical scenes, widely renowned throughout Europe. Painstakingly researched the costumes and settings for his pictures, and used wax models to try out compositions and lighting effects. Also painted portraits, and religious themes.

Richard Eurich (born 1903)
Born and brought up in Bradford and Ilkley, Yorkshire. Studied at Bradford School of Art and the Slade School in London. Began with intense figure drawings, but moved to coastal and harbour scenes. Official war artist during World War Two, painting the war at sea, and especially survival. Turned afterwards to landscapes, and then to pictures based on childhood memories. Illustrated Shell and BP guides to the countryside.

Sir Luke Fildes (1844-1927)
Studied painting as a pupil-teacher at Warrington Art School, and later in London. Began his career with black and white illustrations for journals. At first concentrated on painting scenes of hardship and poverty, but later preferred scenes of everyday life in Venice (following a holiday there), and society and royal portraits.

William Powell Frith (1819-1909)
Began by painting scenes from history and literature, but came into his own with pictures of contemporary life, full of incident and meticulously-recorded detail. His scenes of Victorian life were immensely popular, and frequently had to be roped off at exhibitions to protect them from enthusiastic crowds.

John Martin (1789-1854)
Painted visionary landscapes, many on a grand scale, on biblical and mythical subjects, in particular those involving powerful forces of God and nature, and of death or destruction. Made illustrations for the Bible and for Milton's *Paradise Lost*. His work was popularized through engravings, and he enjoyed considerable success and fame in his lifetime.

John Everett Millais (1829-96)
Founder-member of the Pre-Raphaelite Brotherhood. A child prodigy, he became the most successful of the Pre-Raphaelite painters, gradually abandoning awkward poses and meticulous detail in favour of sentimental anecdotal works (the most famous being *Bubbles*, later used by Pears for advertising) and society portraits, both of which brought more income.

Claude Oscar Monet (1840-1926)
French painter, one of the founders of Impressionism: criticism of his *Impression – Sunrise* gave the movement its name. Worked mostly in France, except for two notable visits to London that resulted in paintings of the Thames. Painted a number of series, exploring different effects of changing light and atmosphere on the same subject, whether haystacks, stations, rivers, or a cathedral.

George Morland (1763-1804)
English painter of landscapes, and especially of rural and village life scenes, which were reproduced and popularized through engravings. Trained with his father, Henry Morland, a London-based painter of domestic scenes.

William Rothenstein (1872-1945)
Bradford-born son of Jewish immigrants. Studied in London and Paris, where he met French artists through his friendship with James Whistler. Early paintings, particularly interior scenes, reflected Whistler's subdued tones, but later work, including landscape, was more colourful.

Sir Peter Paul Rubens (1577-1640)
One of the greatest painters of his age (although his fleshy nudes don't appeal much to today's lean taste). Trained in Antwerp, but visited Spain and Italy, which had a great influence on him. Brilliant draughtsman and highly-skilled, prolific painter; made designs for tapestries, and for ceiling paintings in churches and palaces. Immensely successful, he had a studio of assistants to help complete his numerous commissions.

Jacques Joseph (James) Tissot (1836-1902)
Painted historical-costume pieces and became renowned for his illustrations to the life of Christ and the Old Testament, but is best known today for his meticulously-detailed contemporary scenes. Studied in Paris, where he became very successful; fled to London in 1872 after the Franco-Prussian war, and stayed there until 1882, when he returned to Paris.

Paolo di Dono, called Uccello (c.1397-1475)
Florentine Renaissance painter, mosaicist and craftsman. Trained in the workshop of Lorenzo Ghiberti, sculptor and painter. Very interested in geometry and perspective, which dominate his wall and panel paintings.

Alexander von Wagner (1838-1919)
Born in Hungary; studied in Vienna, and in Munich at a school specializing in historical paintings on a grand scale. Concentrated mostly on painting scenes from ancient history.

Joseph Wright of Derby (1734-97)
Born in Derby, and lived there most of his life, except for a period of study in London (under the fashionable portrait painter, Thomas Hudson), a visit to Italy, and a few years in Bath. Experimented with the depiction of different light effects in paintings, but also studied portraits and landscapes.

William Frederick Yeames (1835-1918)
Born in Southern Russia, where his father was Consul. Studied in London under George Scharf; spent several years in Italy. Painted historical scenes, especially of well-known events from English history, using appropriate costumes and other props. Like Tissot, lived in Grove End Road, St. John's Wood, a favourite location for artists.

Index

A
Alchemist, The / 46-9
alchemy / 49
anatomy / 25
And When Did You Last See Your
Father? / 65-6
animals / 11, 24-5
Amsterdam / 25
Arabian Nights / 16
Arezzo / 37
Artist, The (magazine) / 32
Ascott-under-Wychwood / 9
Australia / 5, 14, 32, 39
Avercamp, Hendrick / 5, 54-7, 70

B
banking / 37
Battle of San Romano, The / 25, 34-7
bicycles / 40-1
Boleyn, Anne / 69
Bradford / 39
Brangwyn, Sir Frank / 5
Budleigh Salterton / 14

C
Caravaggio / 46
cartoon / 9
castle / 54
casual ward / 21
Catholicism / 11
Catherine of Aragon / 69
cavaliers / 64-5
Channel, English / 11
Chariot Race, The / 60-3
Charles I, King of England
(1600-49) / 64-5
clothes / 8, 18, 22-3, 26-9, 32-3, 37, 51,
57, 60, 65
Crystal Palace / 26

D
Delaroche, Hippolyte / 69-70
Derby / 46
Doll's House, The / 58-9
Dudley, Robert, Earl of Leicester / 11
Duke of Northumberland / 68

E
Edward VI. King of England
(1537-53) / 68-9
Elizabeth I, Queen of England
(1533-1603) / 11, 69
Eurich, Richard / 39, 70

F
Faringdon / 11
Fildes, Sir Luke / 20-3
Fire of London, The / 42-5
Flatlow, Victor Louis / 26-7
flowers / 32-3
France / 9, 11
Frith, William Powell / 26-9, 70

G
Gare St. Lazare / 26
Gay Lane / 39
Graphic, The (magazine) / 23

H
Hamlet, Prince of Denmark / 32
Henry IV, King of France 1553-1610) / 11
Henry VIII, King of England
(1491-1547) / 57, 60-3, 69
horses / 11, 37, 24, 53
Houseless and Hungry / 20-3
Hungary / 11, 62

I
Ibsen, Henrik / 58-9
ice / 56-7
Ilkley / 39
Impressionism / 29, 57
Italy / 9, 37

J
John, Augustus / 59

K
Kalasrade / 16, 19
Krogstad, Nils / 58
Knewstub, Alice / 59

L
Lady Jane Grey, The Execution
of / 66-9
Laertes / 33
Lion Hunt / 24-5
lions / 25
light / 28-9, 37, 46, 49, 51
London / 26, 42-5, 52-3
Lucca / 37

M
Martin, John / 16-19
Mary I, Queen of England (1516-58) / 69
Medici family / 37
Millais, John Everett / 32-3, 70
Monet, Claude / 26, 28, 29, 70
Morland, George / 7, 70
Morton, William Scott / 26
Munich / 62
music / 11, 39

N
Netherlands / 11

O
Ophelia / 30-3
Oriel College, Oxford / 9

P
Paddington Station / 26
Padua / 11
Parliament / 65
Persia / 18
perspective / 37, 65
Phillip II, King of Spain (1527-98) / 11
phosphorus / 46
Pisa / 37
Pistoia / 37
Pudding Lane / 45

R
Railway Station, The / 26
Ridley, James / 16
River Thames / 56
Rome / 60, 62
Rothenstein, William / 58-9, 70
Roundheads / 64-5
Royal Academy of Art / 23
Royalists / 64
Rubens, Peter Paul / 25, 70

S
Sadak / 16-19
St. Paul's Cathedral / 45
Science / 46, 49
Second World War / 39
serpent / 25
shadowgraph / 46
ships / 7, 11
Siddal, Lizzie / 33
Siena / 37
Sir Henry Unton / 8-9
skates / 56-7
sketches / 25, 39
Slade School of Art / 59
soldiers / 37
Southwold / 12-14
Spain / 11, 15
Spencer, Sir Stanley / 12-15
swimming / 14

T
Tales of the Genii / 16
Tate Gallery / 5
tinder-box / 44
Tissot, James / 50-3, 70
Tolentino, Niccolo Maurizi da / 37
tone / 49
Too Early / 50-3
Torvald, Norma and Helmer / 58-9
Tuscany / 37

U
Uccello, Paolo / 25, 34-7, 70

V
Van Gogh, Vincent / 23
Venice / 11
Victorians / 23, 32, 69

W
Wadley House, Berkshire / 11
Wagner, Alexander von / 60-3, 70
Wales / 14
Waters of Oblivion / 17
Winter Scene with Skaters near a
Castle / 5, 54-7
Wreckers, The / 6-7
Wright, Joseph / 46-9, 70
Wroughton, Dorothy / 11

Y
Yeames, William Frederick / 64-5, 70

Z
Zutphen, Battle of / 9